VISUAL WORKOUT
CREATIVITY WORKBOOK

VISUAL WORKOUT
CREATIVITY WORKBOOK

Robin Landa
Rose Gonnella

OnWord Press
Thomson Learning™

Africa • Australia • Canada • Denmark • Japan • Mexico
New Zealand • Philippines • Puerto Rico • Singapore
Spain • United Kingdom • United States

NOTICE TO THE READER

Delmar Staff:

Business Unit Director: Alar Elken
Executive Editor: Sandy Clark
Development Editor: Jeanne Mesick
Editorial Assistant: Fionnuala McAvey
Executive Marketing Manager: Maura Theriault
Marketing Coordinator: Paula Collins

Executive Production Manager: Mary Ellen Black
Production Manager: Larry Main
Art/Design Coordinator: Rachel Baker

Printed in the United States
7 8 9 10 XXX 06 05

For more information, contact Delmar, 3 Columbia Circle, PO Box 15015, Albany, NY 12212-0515; or find us on the World Wide Web at http://www.delmar.com

International Division List

Asia:
Thomson Learning
60 Albert Street, #15-01
Albert Complex
Singapore 189969
Tel: 65 336 6411
Fax: 65 336 7411
Japan:
Thomson Learning
Palaceside Building 5F
1-1-1 Hitotsubashi, Chiyoda-ku
Tokyo 100 0003 Japan
Tel: 813 5218 6544
 Fax: 813 5218 6551
Australia/New Zealand:
Nelson/Thomson Learning
102 Dodds Street
South Melbourne, Victoria 3205
Australia
Tel: 61 39 685 4111
Fax: 61 39 685 4199
UK/Europe/Middle East:
Thomson Learning
Berkshire House
168-173 High Holborn
London
WC1V 7AA United Kingdom
Tel: 44 171 497 1422
Fax: 44 171 497 1426

Thomas Nelson & Sons LTD
Nelson House
Mayfield Road
Walton-on-Thames
KT 12 5PL United Kingdom
Tel: 44 1932 2522111
Fax: 44 1932 246574
Latin America:
Thomson Learning
Seneca, 53
Colonia Polanco
11560 Mexico D.F. Mexico
Tel: 525-281-2906
Fax: 525-281-2656
South Africa:
Thomson Learning
Zonnebloem Building
Constantia Square
526 Sixteenth Road
P.O. Box 2459
Halfway House, 1685
South Africa
Tel: 27 11 805 4819
Fax: 27 11 805 3648

Canada:
Nelson/Thomson Learning
1120 Birchmount Road
Scarborough, Ontario
Canada M1K 5G4
Tel: 416-752-9100
Fax: 416-752-8102
Spain:
Thomson Learning
Calle Magallanes, 25
28015-MADRID
ESPANA
Tel: 34 91 446 33 50
Fax: 34 91 445 62 18
International Headquarters:
Thomson Learning
International Division
290 Harbor Drive, 2nd Floor
Stamford, CT 06902-7477
Tel: 203-969-8700
Fax: 203-969-8751

Library of Congress Cataloging-in-Publication Data
Landa, Robin.
 Visual workout : creativity workbook / by Robin Landa and Rose Gonnella
 p.cm.
 ISBN 0-7668-1364-9
 1. Commercial art--Technique. 2. Graphic arts--Technique. 3. Creative ability--Study and teaching--Methodology.
 I. Gonnella, Rose. II. Title.
 NC1000 .L363 2000
 741.6--dc21

 00-030688

dedication

For our students who will be out there creating the visual artifacts of the future.

contents

PART ONE ▸ GET SET

PART TWO ▸ THE WORKOUT

Chapter 5 Work It Out

PART THREE ▸ SHOWCASE

acknowledgments

We would like to thank all the distinguished professionals who contributed their outstanding work to this book — those whose work appears in our show-case and the professionals who took time to test our exercises or contribute to them: Neal Ashby, James Burns, Larry Coffin, Joseph Konopka, Henry Kuo, Laura Ferguson Menza, Alvaro Montagna, Mickey Ricci, Jilly Simons.

Also thanks to our esteemed colleagues, Prof. Martin Holloway and Prof. Stuart Topper, for their generous and wonderful contributions and assistance with this project.

Noted thanks to the generous Kean University students whose work illustrates the exercises. It should be noted here that some of the venerable professionals in this book were our students!

A cracker jack publishing staff always makes authors' lives better and we were fortunate to have one at Delmar. Special thanks to Acquisitions Editor Thomas M. Schin, for his support and foresight to know a good idea when he saw it; and much thanks to Nicole Reamer, Larry Main, Fionnuala McAvey, Rachel Baker, Sandy Clark, and Susan Mathews/Stillwater Studio. Thanks to the reviewers who made good suggestions.

Our families and friends were there, as always, to support this project. Rose thanks Mom and Dad Gonnella, Flynn Berry (special assistant), Franco "The B." Holahan (outrageous idea generator).
Robin thanks her handsome husband (and dance partner), Dr. Harry Gruenspan, her beloved mother, Betty Landa, and her sweet baby Hayley Meredith who is Robin's greatest life achievement. Special thanks to Linda Freire and her family for taking wonderful care of Hayley.

Rose thanks her !deaWorks partner, Robin, for being flexible and perennially hip.

Robin thanks her !deaWorks partner, Rose, for being amenable and eternally hep.

About the authors

Robin Landa

Robin Landa is the author of eight published books about art and design, including *Graphic Design Solutions* (Delmar Thomson Learning) and *Thinking Creatively: New Ways to Unlock Your Visual Imagination* (North Light Books).

Most recently, Landa co-authored (with Rose Gonnella and Denise Anderson) *Creative Jolt* and *Creative Jolt Inspirations* for North Light Books. She has won many awards, including the New Jersey Authors Award, The National League of Pen Women, National Society of Arts and Letters, Art Directors Club of New Jersey, The Presidential Excellence Award in Scholarship from Kean University, and Creativity 26.

Landa is Professor of Visual Communications, Department of Design, at Kean University, and is a creative consultant to major corporations. She is included among the teachers whom the Carnegie Foundation for the Advancement of Teaching calls the "great teachers of our time." Landa has lectured across the country and has been interviewed on radio, television, and the World Wide Web on the subjects of design, creativity, and art, and is a columnist for iSyndicate.com. With Rose Gonnella, she is a partner in their firm !deaworks. Robin resides in New York City with her husband, Dr. Harry Gruenspan, and their daughter, Hayley Meredith.

Rose Gonnella

Rose Gonnella is an artist, writer, and educator. A published and exhibited artist, she has shown her work nationally and internationally in both group and one-person exhibitions. Rose Gonnella's drawings are in several permanent collections, including the National Museum of American Art in Washington, D.C. She has illustrated two books entitled *Summer Nantucket Drawings* (Waterborn Group) and *Walking Nantucket* (Faraway Publishing).

In *The Simple Art of Scrapbooking* (Dell), Rose Gonnella combined her skills to co-author, illustrate, and design the book. Along with Robin Landa and Denise Anderson, she wrote *Creative Jolt* and *Creative Jolt Inspirations* for North Light Books. Her recent articles for *Raw Vision* magazine, *Hand Papermaking*, and *Nantucket Magazine* have explored the creativity of artists and the philosophies of art-making.

Gonnella is a Professor of Visual Communications, Department of Design, at Kean University. She maintains a partnership with programmer Larry Coffin in their web design and technology studio, Point Infinity. Rose Gonnella and Robin Landa are partners in their firm !deaWorks.

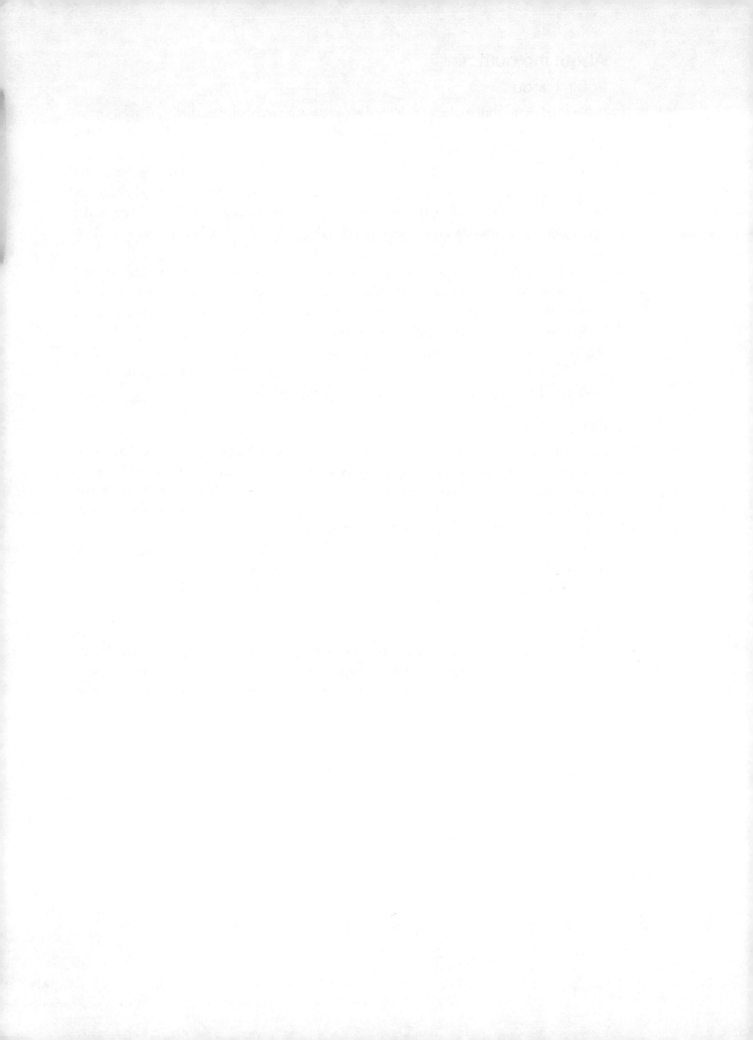

PART ONE ▸ GET SET

1
Introduction

Why should you use a workbook?

Now and then, all professional designers need creative nudges to refresh and brighten their imaginations. Aspiring designers need creative nudges throughout their academic careers to nurture their imaginations.

This book provides stimulation and a visual workout to strengthen creative design muscle. Use this book as a provocateur / workbook / sketchbook / idea file/resource.

As a designer, or for that matter as any creative professional, there's nothing more boring than solving a problem the same way every time. Yet when we become comfortable with a methodology or way of thinking, we tend to stick with it. We may be comfortable, creating tried and true design, but consequently everything looks the same. A safe sameness settles on the work. No design adventures. No design risks. No pushing the proverbial envelope. No warp speed. Same old same old.

This book focuses on experimentation, and provides design adventures for you. It offers a broad array of creative exercises and applications — ways to attack graphic design and advertising problems. There is no one way to find a solution to anything in design; there are an infinite number of ways to solve each problem. The more willing you are to experiment — the more accustomed you become to experimenting — and the better you will be at hunting for and finding a design solution.

Experimenting strengthens the imagination much like lifting weights increases muscle power in preparation for a sport. The weight-training is not the sport in itself, but a necessary supplement to playing well.

The exercises in *Visual Workout* are your way to build design muscle. They are not graphic design applications like designing a book jacket or corporate identity. The exercises are creative problems that stimulate visual thinking, your imagination, encourage sketching and ideation, and foster trying something new.

Sketching in a book is fun. What's also nice is the sense of freedom in placing your drawing tool directly on a page and not dealing with computer technology. Sketching is personal. It's quick. You keep the workbook with you for easy access — to fill a free moment with creative activity.

Most students and designers execute their designs on a computer. They may skip sketching and ideation and jump to the first idea/solution they imagine. An idea notebook is a wonderful complement to the professional/slick looking finish you get from a computer.

Although this book focuses on sketches, or "visual workouts," included are applications to carry some ideas to finished pieces. The applications, at the end of each chapter category, can be executed and used as portfolio pieces.

If you crave a visual workout and creative stimulation, you're in the right place.

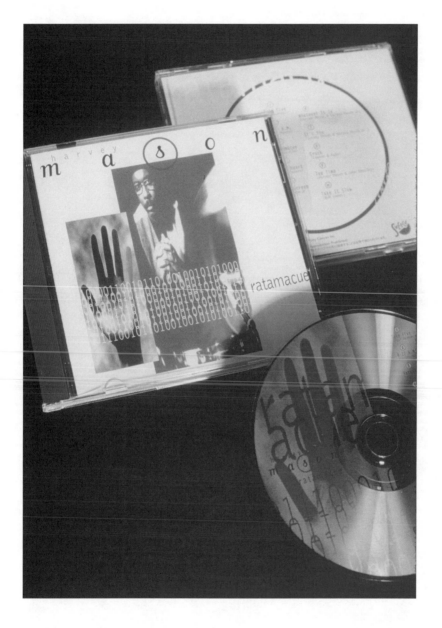

◀ Title: Harvey Mason CD "Ratamacue"
Studio: Vrontikis Design Office, Los Angeles, CA
Creative direction: Petrula Vrontikis
Design: Petrula Vrontikis
Photography: James Minchin
Client: Harvey Mason, ©Atlantic Records
Jazz percussionist Harvey Mason recorded his 4th album, "Ratamacue," whose title references a rudiment used in drumming. The concept combined rudimentary elements of art (his hand) and computer (the binary code) in a unique way to reinforce the new way of producing music traditionally and digitally.

Learn to tap into your creative potential

Why should a designer put effort into finding a creative solution when many clients are satisfied with safe, mimetic solutions to their design problems? After all, if you make the client happy, you get paid — you've done your job. Fortunately, graphic design is more than a service rendered for commerce and industry; it can be an expressive medium.

▶Title: Television com-
mercial titles
Design studio: Segura, Inc.
Chicago, IL
Creative direction:
Carlos Segura
Art direction:
Carlos Segura
Design: Laura Alberts
Client: IQ-TV Atlanta

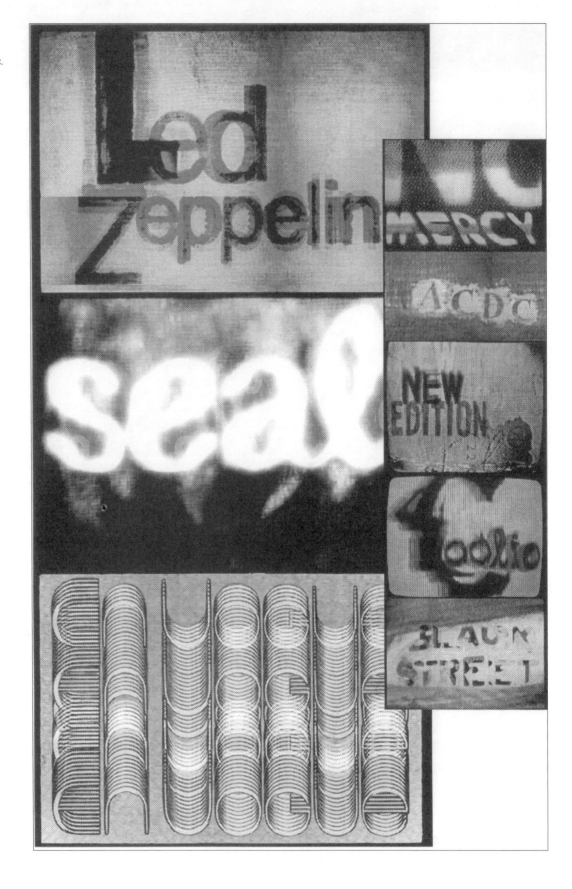

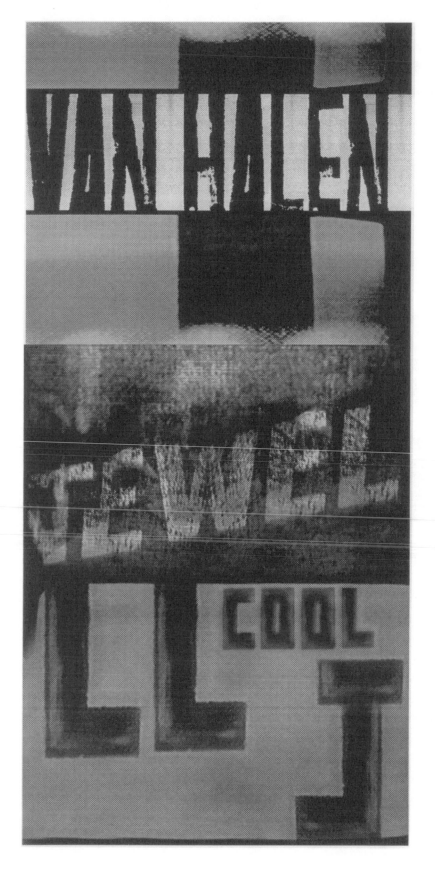

While communicating a message, a graphic designer also may be creatively expressive. One can take a creative leap while doing one's job. That's what makes graphic design such a great career.

Graphic design is ubiquitous. CD covers. Soap boxes. Menus. Posters. Outdoor boards. World Wide Web banners. Television commercials. Magazines. We are surrounded by graphic design, advertising, and illustration. Today, virtually everything that is packaged, promoted, sold, or read is designed. Wouldn't it be just awful if all designers played it safe and we had to look at boring stuff everywhere we turned!

Clearly, graphic designers create the visual artifacts of popular culture. Whether it's the graphics on the side of a truck or a CD cover, the objects created by graphic designers are of historical interest. Graphic designers are the makers of our commercial visual environment and, therefore, have a responsibility to press forward, experiment, and find new ways of seeing and understanding the world.

What do graphic designers do?

Graphic designers solve visual communications problems. They use words and visuals to communicate messages to audiences. The vehicle of the message can be electronic or print.

Electronic media include the Internet, WWW, television, and CD-ROM. Print encompasses editorial design, which includes newspapers, magazines, journals, and books; promotional design, which includes advertisements, corpo-

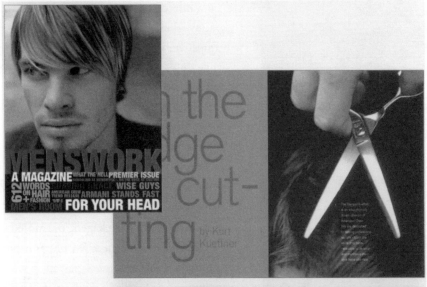

◀ Title: American Crew *Menswork* Magazine
Design studio: Liska + Associates Inc., Chicago &
New York
Creative direction: David Raccuglia
Art direction:
Marcos Chavez, Liska + Associates Inc.
Design: Aimee Sealfon, Liska + Associates Inc.
Photography: David Raccuglia and others
Client: American Crew *Menswork* Magazine
Menswork is a biannual magazine published by
American Crew, manufacturers of quality grooming
products for men. It is directed to professionals in
the salon industry. However, it functions simultane-
ously as a trade publication and as a sales tool pro-
moting American Crew's products to salon clients.
The magazine features innovative trends in hair
care, reports on related fashion trends and editorials
on the hair care profession. *Menswork* is a 60-page,
perfect bound, oversized publication. It uses black
and white duotones and spot silver and gray PMS
colors.

rate identity, logos, packaging, posters, covers, book jackets, web sites, banners, and outdoor boards; and information design which includes maps, charts, graphs, signs, symbols, pictograms, banners, and flags.

In the professional world, a lot of footwork must be done before a designer starts sketching, such as meeting with clients to determine objectives and plan a strategy, determine design criteria, do research, and develop concepts.

Although this books focuses on coming up with ideas and sketching, here is an opportunity to stress the importance of research. Aspiring designers tend to want to go right to ideation without doing any research. When a client does not provide information or enough information, a designer must do research, which can entail going to the Internet and web or library. Thanks to CD-ROM and the Internet, finding information has never been easier.

A designer needs to know about the client's product or service in order to create meaningful designs and make informed decisions. Often a client will provide the research. Sometimes the client expects the designer to be well informed about the product or service and/or do the research. In fact some designers or agencies specialize for this reason, for example, pharmaceutical design and advertising.

Research also entails finding visuals to use in your design solution. Many design students and novices wonder about where they can find visuals. Here are a few suggestions:
• Buy stock photography or stock illustration from stock houses or on CD-ROM.

- Hire a photographer or illustrator.
- Create a graphic visual yourself.
- Do your own illustration.
- Take your own photographs.
- Cut up your own photographs and create a montage.
- Create a collage of found elements (photographs, wrapping paper, textures, newspaper clippings, and so on)
- Photograph old toys, household objects.
- Create a photomontage with image-processing software.
- Create textures with rubbings, blottings, blown-up type or from found visuals.
- Use copyright-free art.
- Use or alter old engravings, orange crate art, vintage postcards, and labels.
- Draw or trace elements from ephemera or vintage graphics, then alter them.
- Buy fonts from good foundries. Beware of poorly designed fonts, overused fonts, and decorative fonts.

What constitutes a creative graphic design solution?

First, let's define an *adequate* graphic design solution so that we understand exactly what makes a solution creative. An adequate graphic design solution does the following:
- answers the client's needs
- has a concept
- is on strategy
- communicates visually and verbally
- employs graphic principles.

Even though one could argue that creativity is illusive, that it can't be pigeon-holed, one certainly can point to the characteristics of a creative or outstanding solution. Here's what three Kean University design professors (in addition to the authors) believe constitutes an outstanding graphic design solution. A creative graphic design solutions does the following:

From Prof. Denise M. Anderson
A Five-Step Formula to Creating an Outstanding Design Project

1. Be energetic. Is your audience compelled to pick it up? Have you grabbed the viewer's attention with something eye-catching such as color, image, or headline?
2. Keep it simple. Does your audience get the intended message immediately?
3. Be original. Is the style, concept, or message unique in its approach in order to separate the product or service from its competition?
4. Be intellectual. Is there a brain (a well thought out concept) behind the beauty (aesthetic graphics)?
5. Be cohesive. Is the message you are communicating united visually (style, type, imagery, color, and so on) and verbally (headlines, body copy, and so on) throughout the piece(s)?

From Prof. Martin Holloway

1. A really good idea must address the problem. Creativity without relevance is self-indulgence.

2. A great idea seems inevitable — natural. An adequate idea seems forced (for example, on-target versus a near miss).

3. Take a chance — playing it safe guarantees mediocrity.

4. A great design (composition — use of visual elements) is always relevant to the message and audience, not just to the designer's taste (for example, compositional style must be appropriate).

5. Always a good hierarchy.

6. Good use of negative space.

7. Great design always uses type appropriately to the job.

8. Great design can break the rules — but the designer has to be able to justify doing this. Personal standards grow from talent, conviction, intellect — this may outweigh practical needs.

9. Great design(ers) show an understanding of type as an extension of language (that is, the voice of type — readability — communication).

10. Great design(ers) also use type as design (composition) and to express meaning (visceral).

11. Outstanding design shows sophistication of taste.

12. Must have good craft — use of materials, tools, technologies.

13. Must reflect the designer's personal aesthetic.

14. Must be relevant to the objectives, to the audience.

15. Must be well-composed. It comes down to:
 - ideas/intellect
 - taste
 - visual sensitivity
 - craft and technique.

From Prof. Alan Robbins

1. Concept — innovative, not the standard cliché you'd expect to see

2. Composition — unexpected manipulation of the elements in their space (new way of layering, maybe, or intersecting forms)

3. Type — an extra effort (beyond simple typesetting) toward manipulating the type for expressive impact

4. Image — unusual or new way of presenting or treating the image for visual impact and symbolic effect

5. Content — reaching outside the usual frame of reference to make connections with other fields, areas of human life, the bigger picture, and so on

From Prof. Rose Gonnella

1. Skillful execution of hand and computer production

2. Seamless use of design principles

3. Conceptually appropriate and challenging

4. Visualization of the concept with a treatment of forms never seen before, or used in a way that has never been seen before; in other words, original, fresh, bright, an instant WOW.

From Prof. Robin Landa

1. Concept works and is believable, clear and smart

2. Strategy fits client needs, audience, market niche, stands out from competition

3. Synergy between what is said and what is shown

4. Visual makes us see something in a new way

5. Type does not depend on a novelty face to carry the spirit of the design; thoughtful, unusual choice of type; thoughtful spacing in both inter-letter and interline

6. Synergy of type and visual — aesthetically and conceptually

7. No clichés

8. Seduces, surprises, attracts, or delights viewer

9. Relevant to the zeitgeist

10. Makes other designers drool

11. Execution enhances idea

These things happen when a designer is willing to experiment, take risks, and jump into the unknown.

2
How and Why to Use This Book

Please note that the examples/illustrations furnished with the exercises are meant to help explain the problems to be solved and to guide you. The examples are not — by any means — the only answers. There are a bazillion answers to any design problem. Please do not copy the examples and try not to be influenced by them. If necessary, cover them while working.

The two main activities in this workbook will be ideation and sketching:

Ideation

A concept or idea is the fundamental underlying thinking behind a piece; it's your idea plan, your brain-creation.

Thinking up a concept is the difficult part of the creative process. It is the part that separates designers, separates the mediocre from the creative. Ideation is difficult because it involves problem solving and creative visual thinking.

A concept is born of instances or occurrences. It can come to you in a flash or you can struggle with it. At times an everyday thing, like a conversation or a storefront, can trigger a concept. You can formulate it or stumble upon it. You can discover it while doing research or talking to the client.

Essentially, a concept means you have a reason for what you are doing, for the imagery and colors you are selecting, for cropping something or using a particular font. It's the framework for all your design decisions.

Sketching

Graphic designers can take a concept and make it visual and comprehensible in a design.

When designing, most designers go through three fundamental steps: sketches, roughs, and final comps. (Comp is short for comprehensive.) Although this book focuses on concept development and creating sketches and roughs, let's go over the definitions and differences among the three steps.

Step 1. Sketches

Thumbnail sketches are small, rough drawings of your visual ideas.
Type is generally indicated. Visuals are very sketchy, created in B/W or color. At this point, try to focus on visualizing ideas and composing, rather than focusing on type choices. Thumbnails are small (a.k.a. the nomenclature), but should be big enough to judge and "read."

Step 2. Roughs

The next step is making roughs, which yield a clearer picture of the design. Usually, a rough is done in actual size or in scale to the desired final piece. Here, type is rendered or generated so that a decision about the appropriate face, spacing, and sizes can be made. Colors are clearly indicated. Imagery is clear. Everything is clear enough to make a decision about which concept, composition, type, and visuals work.

The client does not see this step. A client is shown a more refined comp — the final comp. Roughs are for the designer's and/or design director's eyes. Since most designers create their roughs on the computer, they have the same level of finish as a final comp so they look like final comps! Today, the difference between a rough and final comp is this: In a rough, design decisions about visuals, type, and composition are still probationary. In a final comp, all decisions are final; the designer is satisfied with the concept and execution.

Step 3. Final Comps

Final comps are the next step and usually look as close to a printed or finished piece as possible. Computers allow a designer to create great comps, and now, most clients expect to see comps that look like finished pieces.

In this book, there are applications that you may bring to a final comp. You or your instructor may want to take many of the book's workouts to a finish as well.

Why *Visual Workout* is a great resource:

- It fosters ideation.

- This book is great for in-class warm-ups.

- This book focuses on experimentation, hunting for and finding a design solution. It discourages the feeling that one or two ideas are "precious."

- It provides design adventures.

- It keeps you involved during long studios.

- This is a perfect in-class starting point for an assignment that needs to be finished outside of class.

- It is perfect for small group critiques.

- It stimulates visual thinking and imaginations.

- It encourages trying something new.

- It encourages the idea of a source book — that a notebook is a valuable resource.

- Books can be assigned and collected — a semester assignment, either a self-starter or specifically assigned.

- It gives value to sketching.

- It makes sketching personal.

- It's quick.

- It fosters on-the-spot creativity.

- It fills in gaps or lulls in studio time. You can always work in your *Visual Workout* book if you finish an in-class assignment before the rest of the class.

- It fosters risk-taking. You are more willing to take risks and jump into the unknown when it's an exercise and not an application or huge assignment.

The Nantucket Arts Alliance "N" —
a case study from designer Martin Holloway

THE PROJECT

As an island accessible only by ferry or airplane, the sea profoundly defines the character of Nantucket.

The Arts Alliance brings together performing arts groups, all of which provide an outlet for creative expression.

I was asked to design a logo for this group. As the official signature and identifying mark, a logo should capture the personality of the organization, and it should be memorable.

THE OBJECTIVES

Successful design solutions usually begin with an accurate assessment of communication objectives. In this case I determined these to be the visual expression — first, of the sea, and second, of creativity. These are two key factors in this organization's character.

Clearly assessing communication objectives is critical, but this is wasted if the resulting design is not memorable. This is the point when each designer's personal creative process takes over, the intuitive "this works, this is it" moment when ideas take physical form.

VISUALIZING THE IDEA

This project is a typical example of my own process. The expression of the sea should be symbolized — and should also be a direct expression of the subject; not a literal "picture" of water. This could happen in two ways: first, a fluid, spontaneous brushstroke is a direct mark made with watery ink; second, the letter N written in script form has a shape reminiscent of a wave. The second element of the organization's character, creativity, is also suggested by the brushstroke. A spontaneous stroke with a loaded brush is one of the most elemental gestures possible. It is like part of the DNA of the visual arts — a fundamental building block of all drawing and painting. It is also, especially in Asian painting, recognized as an art in itself, with all creative expression reduced to an instantaneous confluence of emotion and skill.

THE FINAL IMAGE

I have just given a rationale for a direct brushstroke becoming a symbol of the sea and of creativity. However, the "stroke" as seen in the final version of the logo is not a direct, spontaneous brushstroke; rather, it is a meticulously rendered drawing, a simulated pseudo brushstroke. Why? A practical answer is that by redesigning the stroke, one can keep shapes simple and white spaces open, ensuring better quality reproduction at small sizes. A better answer is a more philosophical one, one which is revealing not just of my own approach to design but also of the state of design and popular culture today.

PHILOSOPHY AND DESIGN

Things are not always what they seem. The visual arts in the postmodern era are filled with visual "quotes" from history and multiple styles of pictorial rendering techniques. Early 20th century modernists rejected imagery and historicism and created a new visual language of reductivist geometric form, which they viewed as the authentic and original expression of the century. This was style rooted in philosophy, not in personal taste. Many artists and designers today, while using much of the formal language of the modernists, accept a much more pluralistic definition of what constitutes valid artistic statement, in contrast to the unyielding antipictorial dogma of many modernists.

Embedded in this philosophy is the use of ironic content to express the complexities and contradictions of our era.

The "rendered spontaneity" of the Nantucket Arts Alliance "N" is certainly not an intentionally didactic statement about the condition of postmodern culture. It is, however, an image of its time. The concept is decidedly modern: reducing the essence of an organization to a single symbolic form. The realization of the idea, however, uses imagery that is distinctly postmodern in its use of irony. This image allows a merely rendered illusion of a brushstroke to replace the innate and virtuous natural beauty of the real brushstroke. It implies a triumph of virtual reality over actual reality, of what appears to be rather than what actually is.

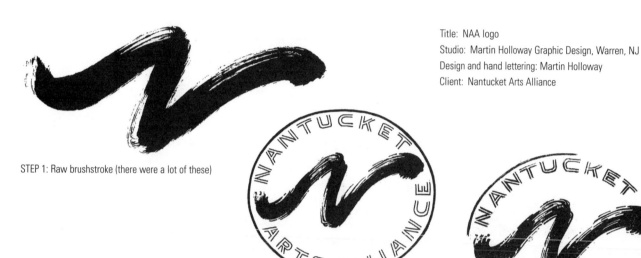

Title: NAA logo
Studio: Martin Holloway Graphic Design, Warren, NJ
Design and hand lettering: Martin Holloway
Client: Nantucket Arts Alliance

STEP 1: Raw brushstroke (there were a lot of these)

STEP 2: Comprehensive shown to client along with several other concepts; original brushstroke crudely retouched for clarity

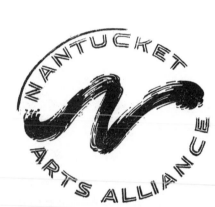

STEP 3: First tracing in development of finished art; "N" was later revised

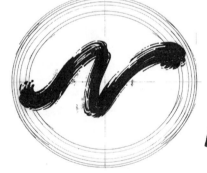

STEP 4a: Final tracing for preparing the finished art — with guidelines for hand-lettered type in the oval

STEP 4b: Tracing development of hand lettering — step prior to doing finished lettering

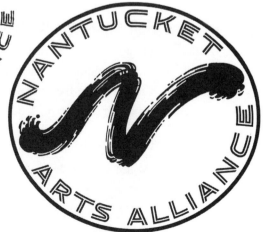

STEP 5: Finished design

chapter

3

Critique Guide

How to critique your sketches for the exercises

Assessment is part of designing. A designer needs to determine the value or significance of what he or she has created. In design, there is a bottom line: design must communicate an intended message to an audience, usually a mass audience. For this reason, it is imperative that a designer's work is on track, intelligible, and communicative. Here are six simple critique checkpoints to follow for the short exercises in this book.

1. Define the problem.

- Restate the problem in your own words. Namely, what are you being asked to do?
- Did you solve the problem?
- Did you go astray? If so, how can you get back on track?
- What is your concept(s)?
- Explain how you solved the problem.

2. How many sketches did you do?

Try to push your ideas. Perhaps your first sketch is intelligent; however, the point of doing many sketches is to push your design-mind further — to stretch your imagination and problem-solving capabilities. There is always more than one great solution.

3. Are your sketches clear enough for someone else to be able to "read" them?

Thumbnail sketches are crude indications of your visual ideas. The key word is visual. A sketch isn't a finish; although, it should have enough visual information — be delineated clearly enough — for someone else to know what you mean, to visually interpret it.

4. Did you explore the possibilities?

Do you have more than one idea or are your sketches variations on one answer?

It absolutely pays to have more than one idea. In practical terms, if this were a real job, the client may not like your one idea and then you would be stuck without a backup solution. Besides, it's challenging to push oneself to come up with many ideas.

5. Are your design sketches visually interesting?

Would your design capture someone's attention and hold it long enough to communicate the intended message?

Creating graphic impact is necessary. Graphic impact is achieved when the elements and principles of the design language are utilized and serve the design concept. Graphic impact can be loud or soft, classic or unconventional. Ask yourself: Is the design compelling?

6. Are your visual concepts fresh?

Did you redo things you've seen before or did you pave your own road? Fresh visuals aren't only innovative ones. Very easily, an interesting color palette, a disarming visual, an uncustomary type choice or combination can yield a fresh visual idea.

How to critique your comps for applications

It is extremely useful to be able to analyze your own work. By ensuring you're on target, you can avoid wasting time (which, in essence, means money). Especially during the stage of concept development, it is crucial to make sure you are meeting the client's objectives and not moving in an oblique direction.

Ask yourself or your team the following.

During concept development

1. Defining the concept

 • What is your idea? Define it.

 • You should be able to articulate the idea in one coherent sentence.

2. Answering objectives

 • Does the concept answer the client's needs?

 • Is the concept on target for the audience?

 • Is the tone appropriate?

 (The tone can be formal, zany, comical, serious, sophomoric, informal, irreverent. Whatever it is, it should meet the client's needs.)

3. Is your concept creative?

 • Did other people in your class or on your team come up with the same concept? (If so, that usually means it's predictable — not a good sign.)

 • Is your concept overused? Have you seen it before? If so, in what context? Ask others if your concept readily reminds them of one they've seen.

 • Is your concept fresh or have you merely relied on a cliché? (At times, you may not realize your work relies on a cliché until you ask yourself this question.)

 • Is the concept intelligent?

 • Is it believable?

During the design stage

1. On Composition

 • Is there an unexpected manipulation of the elements in their space (new way of layering, intersecting forms, and so on)?

 • Is there a clear visual hierarchy?

 • Is there a focal point?

 • Did you establish unity?

 • Did you consider variety within the unity?

 • Is there rhythmic flow from one element to the other?

2. On Type

- Did you make an extra effort (beyond simple typesetting) toward manipulating the type for expressive impact?

- Is the type computer generated? If so, did you kern the letter spacing and adjust line spacing?

- Did you make a thoughtful, unusual choice of type?

- Are you depending on a novelty face to carry the spirit of the design?

- Have you taken the time to create your own typographic spirit?

- Does the type complement the visual(s)?

3. On Image

- Did you find an unusual or new way of presenting or treating the image for visual impact and symbolic effect?

- Is the visual overused?

- Did you consider trying a creative approach, like juxtaposing different visuals, combining visuals, or cropping visuals?

- Does the visual complement the type?

- Did you use special effects for a specific expressive purpose that makes sense relative to your concept or are the special effects unrelated decorations simply because you think they are cool looking?

General points to review and evaluate

- On Content: Did you reach outside the usual frame of reference to make connections with other fields, areas of human life, the bigger picture?

- Did you establish synergy between what is said and what is shown?

- Does the visual make us see something in a new way?

- Is there aesthetic and conceptual synergy between type and visual?

- Did you avoid clichés?

- Does your design solution seduce, surprise, attract, and/or delight the viewer?

- Is your solution relevant to the zeitgeist?

- Will your solution make other designers say WOW! *and* drool?

- Does the execution enhance the idea?

PART TWO ▸ THE WORKOUT

chapter

1

Expressive Typography

In order to familiarize a child with an alphabet, parents repeatedly expose a child to the individual letters or characters of their language system. A child learns to recognize the shape of a letter and to associate it with sound and meaning. Letters become ingrained symbols of verbal and written language.

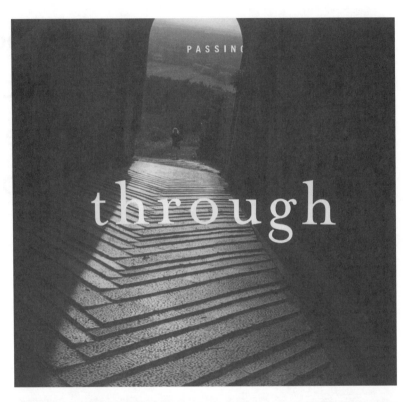

▶ Figure 1-1
Title: B&R, *The World's Great Biking Journeys*
1998 brochure
Studio: Viva Dolan Communications and Design Inc.,
Toronto, Canada
Design: Frank Viva
Writing: Doug Dolan
Photography, principal: Ron Baxter Smith
Photography, additional: Macduff Everton, Hill Peppard,
Steven Rothfeld et al.
Illustration: Malcom Hill
Client: Butterfield & Robinson
The catalogues published annually by Butterfield & Robinson are designed to reinforce B&R's position as the world leader in biking and walking vacations for a sophisticated, upscale North American clientele. A key element in the design solution was the creation of a trip page that communicates a wealth of multi-tiered information in an attractive, easy-to-use format. The trip page is in effect B&R's sole showroom and it must convey all the practical data, as well as the emotional-aesthetic allure, that a client needs in order to make a very high-ticket purchase. At the same time, B&R's catalogue is eagerly anticipated by loyal travelers (repeat business accounts for a large share of annual revenue) who view it as a reflection of their own refined tastes and cultural awareness. Each new catalogue therefore must look great, offering a distinctive visual approach that inclines recipients to keep it on their coffee tables. This year B&R created a heightened sense of occasion by publishing two companion books, *The Great Walks of the World* and *The World's Great Biking Journeys*, underlining the fact that the pioneer in top-quality biking trips now leads the field in walking as well.

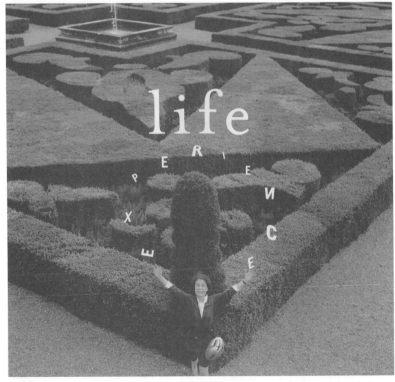

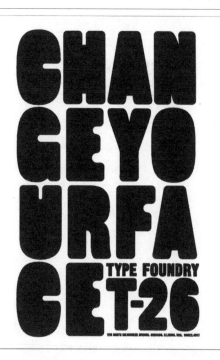

▼ Figure 1-2
Title: "T-Twenty 26 — Change Your Face"
Studio: Segura Inc., Chicago, IL
Creative direction: Carlos Segura
Design: Carlos Segura
Client: [T-26] Digital Type Foundry

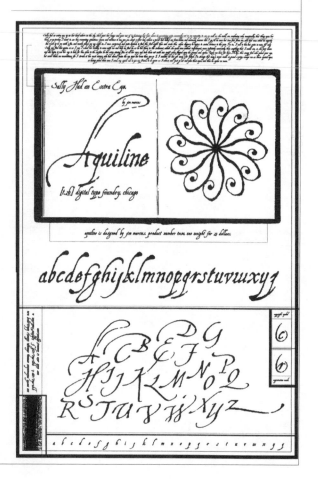

▼ Figure 1-4
Title: Masoch-Dirach, promotional postcard
Studio: Segura Inc., Chicago, IL
Creative direction: Jim Marcus
Design: Jim Marcus
Client: [T-26] Digital Type Foundry

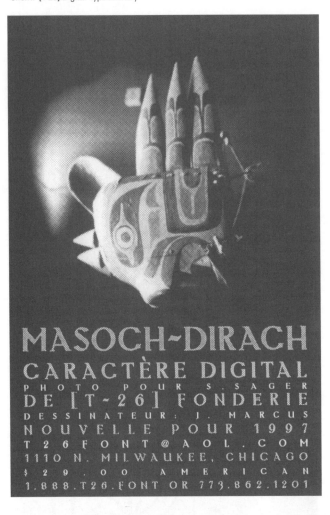

A designer learns that the shapes of letters are expressive far beyond their basic use as sound symbols. Beyond verbal and written language, designers learn to use individual and groups of letters as expressive imagery — a visual language. For example, Viva Dolan's use of type in this Butterfield & Robinson catalogue, *The World's Great Biking Journeys* (figure 1-1). The typographic design of the words "passing through" are thoughtfully scaled and positioned. Similarly, Carlos Segura's and Jim Marcus' designs demonstrate a thorough understanding of the ability of type to become texture and to be expressive (figures 1-2, 1-3, and 1-4).

A design student must spend an extraordinary amount of time revisiting the individual letters of the alphabet in order to heighten sensitivity to their shapes and learn how to use letters as imagery. A successful and creative designer intimately knows every curve, angle, and stroke of letters, along with being well-versed in the use of several (at least five) classic faces. Without a meaningful study of type, a designer is a primitive. Martin Holloway has made typography a life's work. Notice the unique hand lettering in

▼ Figure 1-3
Title: Front and back cover and inside cover panels of *The Alternative Pick* sourcebook
Studio: Segura Inc., Chicago, IL
Creative direction: Carlos Segura
Design: Carlos Segura
Client: The Alternative Pick

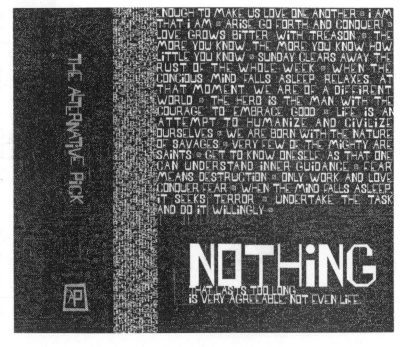

"Robin Landa" and the playful turning of the "A" in parkway into a graphic parkway (figures 1-5 and 1-6).

Graphic designers are not only concerned with the graphic aesthetics of individual letters, but with groups of letters (words), lines of type, inter-letter spacing, and inter-line spacing. Also, designers must be concerned with legibility, readability, expressiveness, spirit, style, classics and trends, appropriateness, and, of course, the graphic principles of unity, hierarchy, balance, alignment, and rhythm.

One only has to study the use of positive and negative shapes in Russell Hassell's cover design, to realize how powerful typographic design can be (figure 1-7). Typographic design can be enchanting as well, for example, Alan Butella's use of letters to become human forms (figure 1-8). Petrula Vrontikis' typographic designs for these gift tags are wonderfully witty and handsome (figure 1-9).

The more you're aware of the shapes of letters and the shapes letters create interacting with each other and the page, the more creative your designs will become.

▼ Figure 1-5
Title: "Robin Landa"
Studio: Martin Holloway Graphic Design, Warren, NJ
Design: Martin Holloway
Lettering: Martin Holloway
Client: Robin Landa

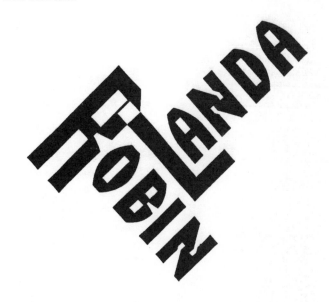

◄ Figure 1-6
Title: "Parkway"
Studio: Martin Holloway Graphic Design, Warren, NJ
Design: Martin Holloway
Lettering: Martin Holloway
Client: Parkway Insurance Company

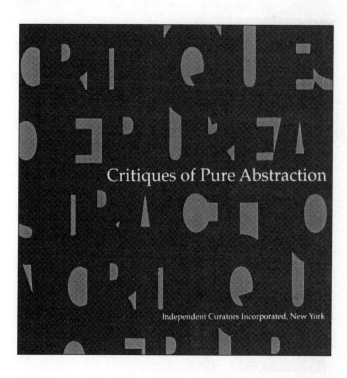

▶ Figure 1-7
Title: *Critiques of Pure Abstraction,* exhibit catalogue cover and spread
Studio: Russell Hassell, New York, NY
Design: Russell Hassell
Client: Independent Curators Incorporated, NYC
To express a postmodern sensibility in *Critiques of Pure Abstraction* — an exhibition catalogue of postmodern artists who use abstraction as both a critical and expressive vehicle — I decided to approach the cover as a formal exercise of typographic positive and negative space but using an odd, gunmetal-blue, metallic chromolux stock with fluorescent orange silkscreen ink.

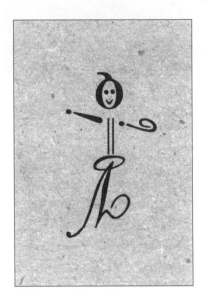

▲ Figure 1-8 ▶

Title: *Lost & Found Figures*

Studio: Circle C Studio, Chicago, IL

Creative direction: Alan Butella

Client: Circle C Studio

A few years ago I began to develop a series of "Characters" based on my typographical explorations using letters, numbers and mathematical symbols. By abstracting letters and symbols from their typical linguistic context, I derived the "Characters" from my gestural doodling with the abstracted text to take on a somewhat recognizable vernacular. The transformation that results from the combination of type families and symbols gives each figure its own unique character. It is precisely that transformation that most interested me in the process.

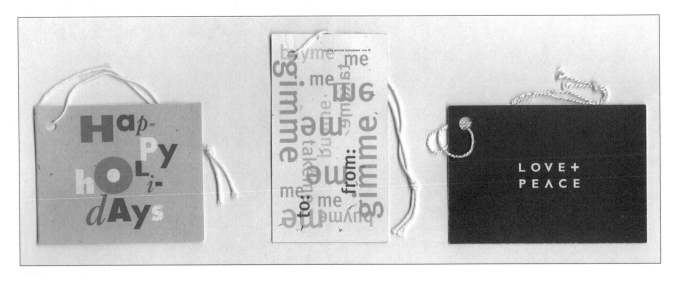

▼ Figure 1-9
Title: Unique tree-free all occasion gift tags "to-from"
Studio: Vrontikis Design Office, Los Angeles, CA
Creative direction: Petrula Vrontikis
Client: Vrontikis Design Office

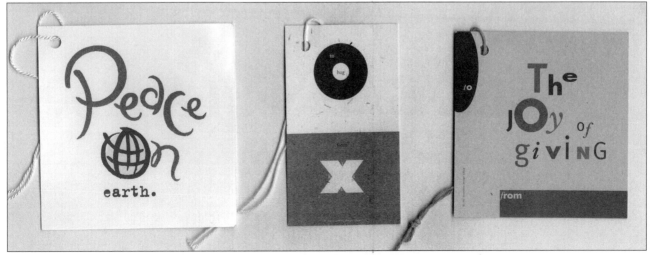

EXERCISES

1. Make a word grow

Use the height, or point size, of type to create various effects and communicate different messages. Differing size relationships not only helps establish a focal point and hierarchy, the relationships can create the illusion of movement, or a sense of the passage of time.

By gradually increasing and decreasing the point size of the type, make a word grow and subsequently shrink. You can draw directly onto the workbook page or generate the type on the computer and trace onto the page.

• *Learning to create the illusion of movement in a type treatment will expand your typographical oeuvre.*

Mary Plunkett

gROW&SHRINk

Bridget Marinaro

GARDENING

Kathy Blake

gLOBALpoPULATIon

2. Stacked type

Some designers who are famous for their captivating typography, such as Herb Lubalin, Bob Farber, and Ed Benguiat, have stacked type in various exciting formats. Research the typography of these designers and copy some of their typographic compositions onto the blank pages in the back of this workbook.

Design one word using narrow inter-letter spacing. The word should begin and end with the same letter. Draw the designed word on tracing paper, vertically flip the word over and trace the reversed letters — stacking below the original. Fill the letters using a black marker. Repeat. Flip the word as many times as you like to form dynamic positive and negative stack of shapes. You may choose to execute this exercise on the computer, print the results, and adhere it to the workbook page.

• *This exercise teaches the importance of positive and negative shape inter-relationships to winning typography.*

Kelly Durow

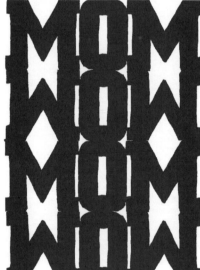

Dawn Pittaro

Keith Dwyer

Cesar Rubin

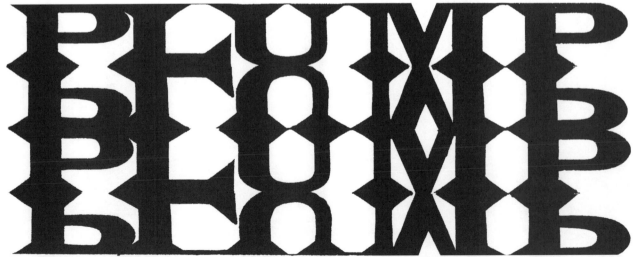

3. Figure ground reversal

Very interesting and surprising shapes can appear when designers give close attention to designing both the positive and negative shapes of letterforms. Logos, headlines, and text type are wonderful when negative (ground) shapes inextricably interact with the positive shapes (figures). For example, Landor Associates cleverly created an arrow in the negative space between the "E" and "x" of the FedEx logo.

Using one or more letters, create a figure/ground design. The letters may touch each other, be cropped off the page, overlap and/or touch the edges of the page.

• *Most designers will agree that the most important graphic principle is positive and negative space relationships.*

Andria Mattsen

Cesar Rubin

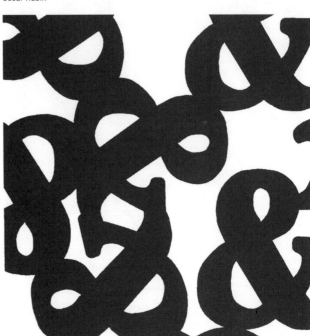

Stacy L. Bober

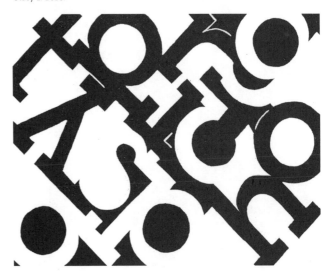

Michael Sickinger

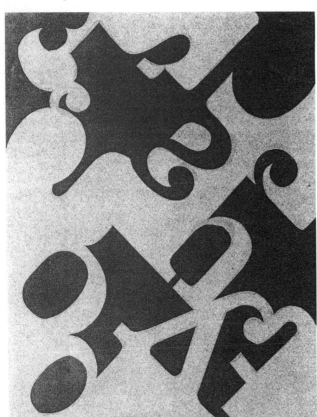

4. Onomatopoeia

Words can imitate the sounds associated with the actions or objects to which they refer, such as murmur or roar. Writers, poets, designers, art directors and cartoonists utilize onomatopoeia for expressive purposes.

Design an onomatopoetic word — a sound word that suggests a sensation. For example, hiss, zap, cluck, or buzz. Design the word to visualize sound.

• *To think of print as a silent medium — although, it is — shortchanges its potential. Design can conjure-up sound as well as, smell and touch, in the mind of the viewer.*

Andria Mattsen

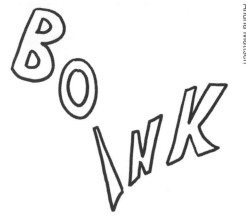

Michael O'Keefe, Graphic Designer, New York, NY

Robin Landa

Branislav Bogdanović

Kelly Durow

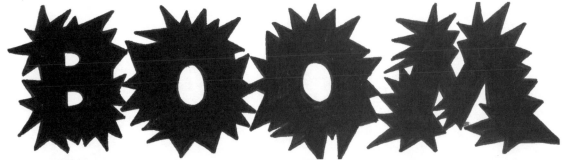

5. Design a 27th letter for the alphabet

The letterforms of the contemporary English alphabet are a distinct related set. The letters, whether in lowercase or uppercase, share many characteristics. For example, a lowercase "c" and a lowercase "e" share common curves.

Design an additional letter for any alphabet. Take care to make sure it shares characteristics of the chosen alphabet and looks like a logical visual member set.

• *This exercise, though particularly difficult, forces you to become intimate with the shapes of the alphabet. This knowledge is crucial for designing with type.*

Dawn Pittaro

Andria Mattsen

Stacy L. Bober

6. Reinvent an ampersand or exclamation mark

Type has a voice. Its shape can speak loudly or softly. Also, it can possess a distinctive personality — it can be flirtatious or shy.

Design an ampersand or exclamation mark so that it possesses a distinctive spirit or personality.

• *A designer can push the outside of the letterform envelope, by altering, adding, or deleting parts of a letterform. The ability to express a spirit or personality utilizing type is central to design.*

Kathleen Thorsey

Steve DeBeus

Lynn T. Wu

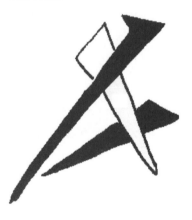

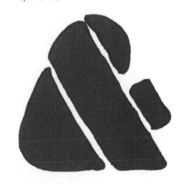

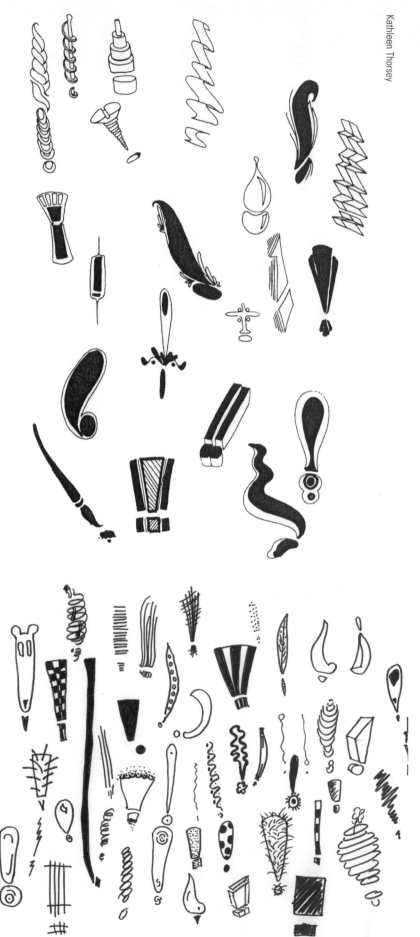

Robin Landa

7. Letter as a representational object

Finding similarities in shapes between letters and objects can be fun. Transforming a letter into an object takes a keen eye for shape and a creative touch.

Take a letter and turn it into a recognizable object. For example, take a lowercase "g" and adapt the shape into a frog. Or, take an uppercase "Y" and turn it into a martini glass. Don't force the transformation; find one that is a natural fit.

• *All visuals, including type, are composed of shapes. One shape can be made to look like or stand for another shape.*

Staci Bacsoka

BODY BOTANICAL

Jim Dryden, Illustrator, Falcon Heights, MN

8. Replace one letter with an object

Often, designers will turn one letter of the word into an object for a special effect or message, for example, the "l" in ballet is replaced with a toe shoe, or the "P" in public morphs into a human profile. This adds an amusing, clever, and attractive element to the typography.

Choose a word and replace one of the letters with an object that refers to or relates to that word. For example, turn the second "b" in baby into a rattle, or turn the "g" in dog into a leash.

• *People are often attracted to typographic design that incorporates visuals. Turning one letter of a word into a visual makes the visual an integral part of the design.*

Andria Mattsen

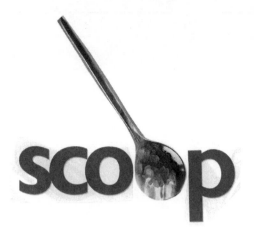

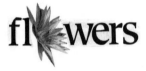

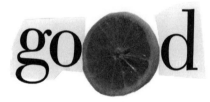

Jason DeAngelis

9. Create type figures

Archimbaldo, an Italian 16th century painter, was noted for creating faces comprised of vegetables. In a similar vein, wouldn't it be fun to create figures comprised of letterforms!

This exercise was inspired by designer Alan Butella of Circle C Studio in Chicago. He created a wonderful book of type figures and patterns, titled *Lost and Found Figures.* It is available through Printed Matter Book Store in New York City, or Circle C Studio in Chicago.

Create figures composed of found, hand-lettered or generated letterforms.

• *Creating figures from letters adds to your ability to make shape and form judgment comparisons about objects and letterforms.*

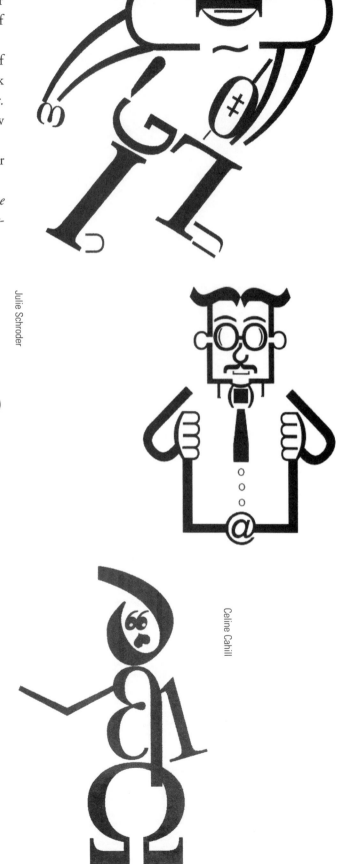

Kenneth A. Banick

Julie Schroder

Steve DeBeus

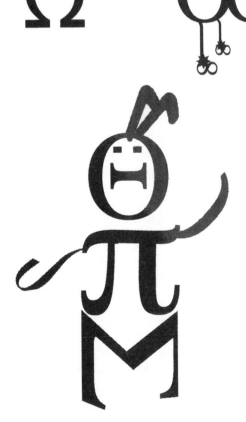

Celine Cahill

10. Creative ligature

A ligature is the inextricable joining of two or more let-terforms. Some fonts come equipped with ligatures. Most seasoned designers prefer to create their own for a unique creative identity.

Choose a word. Join two of the letters within the word to create a ligature. Select a pair that is not common to most fonts.

• *A ligature strengthens the gestalt — the unified feeling of the whole typographic design.*

Martin Holloway, Martin Holloway Graphic Design, Warren, NJ

APPLICATION

There are innumerable fonts available these days, thanks to the computer and software tools. Some designers will base a font on imagery, such as type made up of knives, the human figure, or paper clips.

Design an alphabet based on a particular object(s) or image(s).

• *You can bend, stretch, or manipulate an object into the shapes of letters. Finding an object or image that will work teaches the skill of shape selection.*

chapter

2
Mixed Up Media & Techniques

media: the materials used to create.

techniques: the method of applying the media.

So many images are so easily churned out of computer programs these days, that from California to Australia the graphics created by the software tools seem altogether generic. The great individualism of the "designer's own hand" is in danger of being lost to the standardization generated by a few software packages. Almost.

There is hope that the art and aesthetics of graphic design can still be found in the hands of the designer. The Liberty Science Center poster created by Donovan and Green literally uses an inked imprint of a hand for a bold impact and a personal stamp (figure 2-1).

Illustrator Jim Dryden, scrapes, scratches, strokes with dash, pushes, blends, layers, and scumbles paint over a textured surface to produce a lively visual surface (figure 2-2).

Think. Do you love poring over and examining in detail, all the tools and materials that pack the shelves in good art supply stores? There is an amazing array of paint brushes, paint, printing tools, markers, pencils, inks, cutting tools, and erasers. Are you fascinated by the seemingly endless variety of paper textures and colors available? Did you ever buy a large sheet of Japanese handmade paper just because you liked it, without having a particular use in mind? Or have you taken a printmaking class that wasn't required? Yes? There is hope.

Media — the materials of art, and techniques — the application of materials, can in themselves be the inspirational springboard for a cutting-edge concept in the design of a book jacket, poster, brochure, direct mail folder, and so on. With the stroke of a brush, you might discover the perfect unique mark to make a symbol, logo, or headline. However, you do have to pick up the brush, twig, sponge, or anything else that you can think of to create the mark. To create a celebratory and familiar experience, the graphic imagery on Thomas Ema's set of holiday cards are rendered with quick, thick strokes of a brush; as a complement, the lettering has the look of handwriting (figure 2-3). Carlos Segura uses an inked

▼ Figure 2-1

Title: Poster for interactive exhibit

Design studio: Donovan and Green, New York

Project principals: Nancye Green and Janet Johnson

Client: Liberty Science Center, Jersey City, NJ

Donovan and Green designed the poster for "A Show of Hands," an interactive exhibit (funded in part by the National Science Foundation) created to showcase the importance and uniqueness of the human hand. This 3000-square-foot exhibit will draw on visitors' natural fascination with their own hands while exploring their tremendous capabilities. The human hand is portrayed as a communicator, a hard-working tool for laborers and artists, a key to the personality, a clue at a crime scene, and the subject of an endless variety of music, paintings, and photographs.

The concept behind the poster is to make science fun. The inspiration for the hand print is the above-mentioned fascination people have with their own hands.

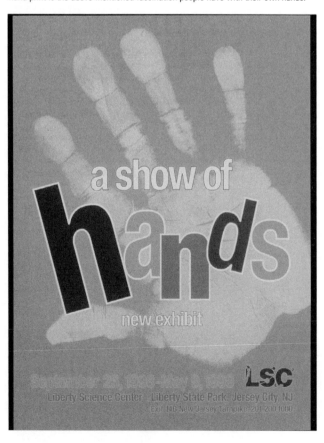

▼ Figure 2-2
Title: Illustration for Herman Miller International brochure
Design studio: BBK Studio, Inc., Grand Rapids, MN
Principal: Yang Kim
Illustration: Jim Dryden
Client: Herman Miller International

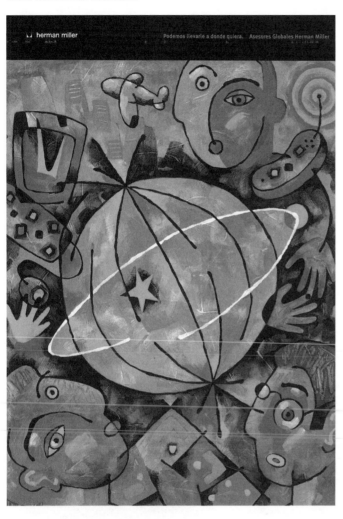

▼ Figure 2-3
Title: Series of holiday theme postcards
Design studio: Ema Design Inc., Denver, CO
Art direction: Thomas C. Ema
Design: Thomas C. Ema, Debra Johnson Humphrey
Illustration: Thomas C. Ema
Client: Artist's Angle Inc.
The postcards serve as a reminder to use the services described on the back of the cards. The approach I chose for the illustration of the post-cards relates to the logo we designed which was created with hand-painted brushstrokes. The goal of these were to relate to the fine artists in this service bureau's clientele.

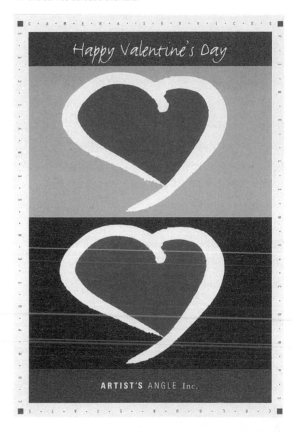

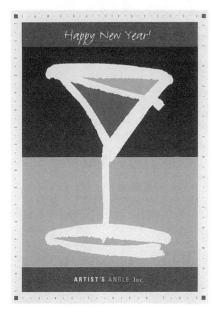

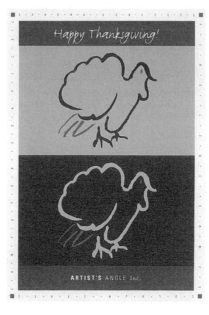

brayer and literally rolls his design onto the surface to create the lettering for several related posters (figure 2-4).

Drawing techniques in a variety of media

The tremendous value of observation, representational visualizing, and expressive drawing should not be underestimated in the field of design. The ability to draw considerably increases your creative range on many levels. Learning how to sketch gives you the ability to quickly visualize many ideas. A drawing technique in itself can suggest or be the solution for a design problem. Finally, designers who can illustrate add a valuable dimension to design studios.

If you're interested in visualizing, then you'll grow creatively. A curious attitude and a joyful willingness to experiment is essential to unleash creative strength. Alvin Wong's promotional ads for the design studio, point **b** incorporated, have soft, overlapping textures and employ a variety of artistic techniques to extend their appeal (figure 2-5). In the logo designs created by Martin Holloway, hard-edge graphic renderings work exceptionally well for a classic styling that complements his hand-lettering (figure 2-6).

Collage techniques

A popular contemporary art and design technique, collage was introduced by Picasso. Collage, meaning to cut, paste, and layer, is a favorite for its personal nature, textural richness, and eclectic styling (anything goes). Carlos Segura employs collage techniques extensively in his designs and achieves a highly personal, richly layered, and, often, unusual graphic vision (figures 2-7, 2-8).

Before you begin this group of exercises, spend some time researching designers and artists who have included collage in their repertoire of techniques. On the blank pages provided in the back of this book, note the variety of materials and methods these creative individuals have used.

Possible research subjects: artists such as, Romare Bearden and Pablo Picasso, and designers such as Paul Rand and Ivan Chermayeff. Chermayeff was once honored with a solo exhibit of his collages at the Corcoran Gallery of Art in Washington, D.C.

▼ Figure 2-4
Title: Posters - part of a series for *The Alternative Pick* sourcebook
Studio: Segura Inc., Chicago, IL
Creative direction: Carlos Segura
Design: Carlos Segura
Client: The Alternative Pick

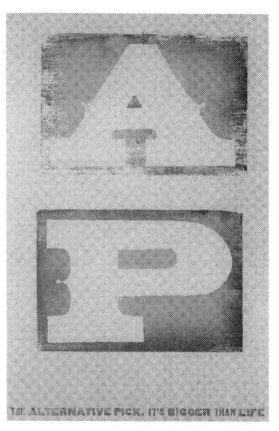

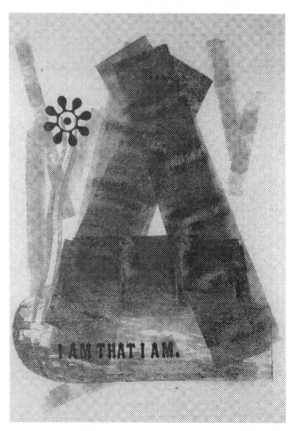

► Figure 2-5
Title: point **b** advertisements
Design studio: point **b** incorporated, Honolulu, HI
Art direction: Alvin Wong
Design: Marlene Lee, Alvin Wong
Client: point **b**
To appeal to a wide variety of audiences, we created a series of ads that differ in artistic style while drawing on different cultural celebrations such as Christmas, for inspiration.

► Figure 2-6A
Title: Logo design
Design studio: Martin Holloway Graphic Design, Warren, NJ
Design: Martin Holloway
Lettering: Martin Holloway
Client: New Jersey Bell

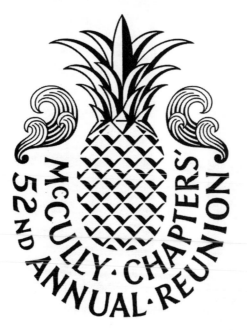

▼ Figure 2-7
Title: LIT 50 bottom cover for Good Seats
Studio: Segura Inc., Chicago, IL
Creative direction: Carlos Segura
Art direction: Susana Rodriguez
Design: Susana Rodriguez
Client: NewCity, Chicago, IL

▼ Figure 2-6B
Title: Logo design
Design studio: Martin Holloway Graphic Design, Warren, NJ
Design: Martin Holloway
Lettering: Martin Holloway
Client: Eno Woods

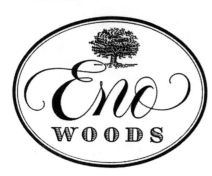

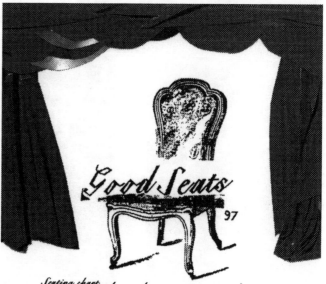

▼ Figure 2-8

Title: Posters (part of a series) for *The Alternative Pick* sourcebook

Studio: Segura Inc., Chicago, IL

Creative direction: Carlos Segura

Design: Carlos Segura

Client: The Alternative Pick

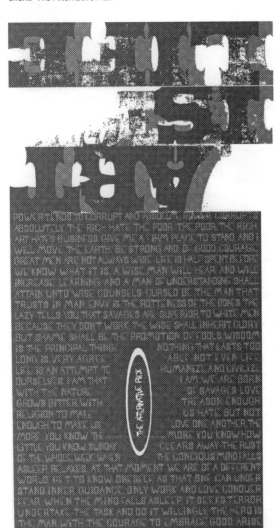

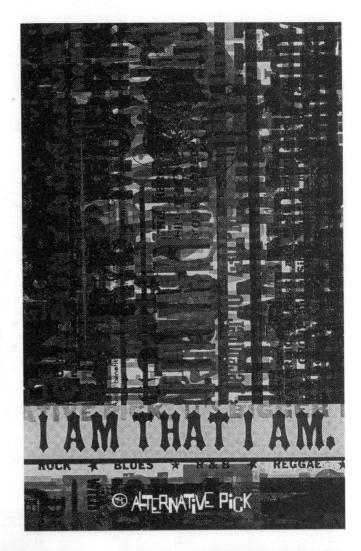

Mixed up media and techniques

Once you combine a painted shape with a line drawing made with crayons, you have a mixed media design. The fastest way of expanding your repertoire of techniques and visual vocabulary is through experimenting with multiple combinations. A collage with paint and additional line drawing from Segura Inc. joins several techniques into a single visual (figure 2-9).

▼ Figure 2-9
Title: Rock the Vote campaign poster, sticker, and postcard
Studio: Segura Inc., Chicago, IL
Art direction: Carlos Segura
Design: Carlos Segura
Client: Q101 Radio, Chicago, IL

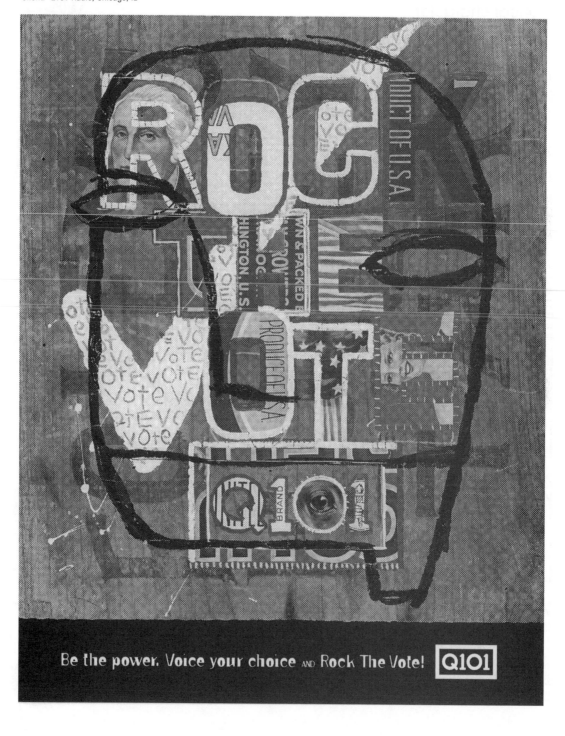

EXERCISES

In this series of 17 exercises, we recommend that you choose a single object to use as your drawing subject. The object you choose can be taken from nature or be man-made. Keep it simple such as a flower, fish, or shoe. By selecting a single subject for all the exercises, you establish a "control" for your drawing experiments. Choosing one object allows you to focus on the variety of characteristics created by a specific media and technique, rather than the problems of rendering many different kinds of forms or drawing many kinds of representational objects. It is important to research your selected subject and gather as many photographic references as possible.

1. Linear character

Contour drawings can be very useful basic images. Used as a spot illustration, they are an inexpensive way of providing visual relief for a gray page of text. The simplicity of a black and white contour is easy to understand and therefore universally appealing.

Primarily used to render a shape or form, line also can expressively define the weight and surface character of an object. Using marker or 2B pencil, draw the outline of your selected subject while carefully delineating contours as well. The lines you make can be long, short, thin, thick, bold, or fragile. Vary the appearance of the line to capture the essential character of the object.

• *A designer who can draw is an asset to any studio. This exercise strengthens your powers of observation and sharpens your ability to draw with line.*

Mary Degnan

Jill Fairchild

Flynn Dellabough Berry

Stacy L. Bober

2. Straight lines only

Experimenting with the greatest variety of techniques possible is not the only way of stretching your visual vocabulary. You also can push creativity by limiting your technique.

In this exercise, create the form of your selected subject with only vertical or horizontal lines. Impose another limit by using a fine point marker that will restrict the line to one weight.

• *Designers are constantly dealing with limitations. When faced with severe restrictions, you can learn to be truly ingenious.*

Michael Sickinger

Layla Reino

Stacy L. Bober

3. Mark it up

Line is a great starting point for a graphic rendering. However, line can wiggle, bend, twist, and be transformed into shapes that are no longer considered lines. The artist Vincent Van Gogh had an astounding vocabulary of simple marks to define complex forms and textures he saw in nature. His pen and ink drawings are a dense fabric of criss-crossing dots, dashes, short strokes, and curls.

Research Van Gogh's pen and ink drawings. Study his use of marks. Using your selected subject or perhaps the landscape outside your window, draw a unique mark for each contour or texture you see within your subject.

• *The purpose of this exercise is to expand your visual mark-making vocabulary. In the process you also learn about a master graphic technique.*

Steve DeBeus

Michael Sickinger

Christopher A. Boscia

4. Brushing the contour

Created with a pen, marker (regular or calligraphy marker), or pencil, line drawings have a blunt and hard-edge appearance. The quality of line created by these tools is excellent for many applications. However, you can soften line for a variety of effects beyond those created by dry media by using brushes and ink.

Most certainly, you are familiar with a pencil or pen contour. In this exercise exchange the familiar hard tool for a soft one. Use a brush and ink or a soft calligraphy marker to draw the contour of your selected subject. Vary the pressure and shape of the line to expressively render the form.

• *The purpose of this exercise is to stretch your drawing skill and vocabulary of line to include the more organic, gestural characteristics obtained using softly flowing brush and ink.*

Shana Leigh Acosta

Layla Reino

5. Brush drawings and hand lettering

In the business of design, images are most often accompanied by some kind of type. Gestural graphics created with ink and brush or a wet calligraphy marker can be complemented by set type. Or, they can work equally well with hand lettering.

In this exercise, draw your selected subject with brush and ink. Hand-letter the name of your subject using the same method as the drawing. You may do many of these studies and afterward choose one duet that works well together to adhere onto your workbook page.

• *The purpose of this exercise is to gain awareness of how one technique can be used to unify different kinds of shapes. You also practice relating type and image.*

Kofi W. Bonner

Paul Doto

Christine Adamcio

6. Revisit childhood

Everyone wishes they had the freedom of a child. In experimenting with media and techniques, use this exercise to revisit your childhood in search of innocence and playfully abstract form.

Children are concerned with the expressive and essential nature of their subject rather than an exacting representation. With a large crayon in hand and a playful attitude in mind, draw your selected subject in a childlike way.

• *Tapping into a childlike vision of the world adds a whimsical level to your visual vocabulary.*

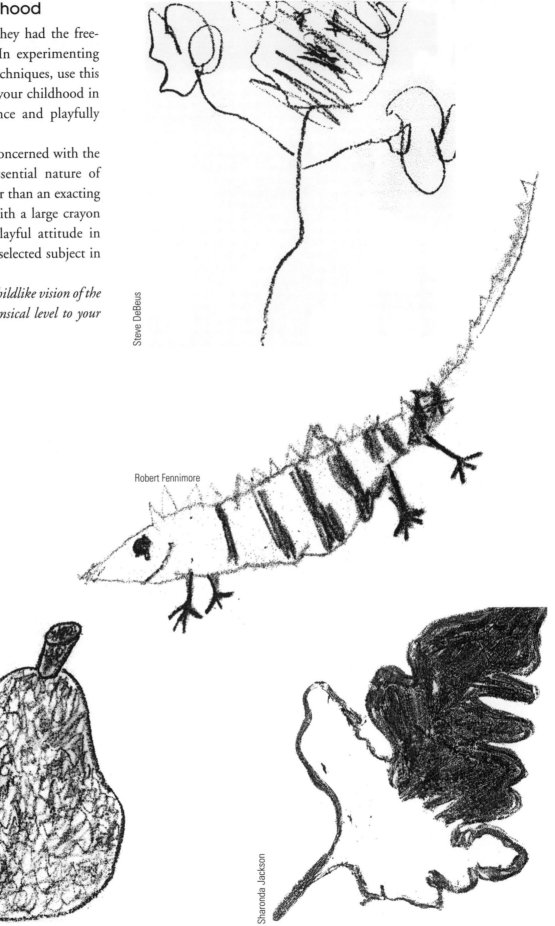

Steve DeBeus

Robert Fennimore

Sherida Martin

Sharonda Jackson

7. Full range

Drawing and design students have a tendency to hover in the middle zone of a tonal range when modeling form. Most of their drawings are a smear of gray tones. Light areas are obliterated by the smudging technique of pushing graphite around with a finger in order to fill it in an outline. With this poor technique, light areas are lost and dark areas never quite reach blackness. Highlights, a full range of middle grays, and black is necessary for a rich tonal drawing.

The media can help improve your drawing technique in this exercise. Rather than using varying pressure with one pencil, use 8B, 6B, 2B, HB, F, 2H, 5H, and 9H pencils to achieve a full range and control over gray tones. As you draw your selected subject be highly aware of preserving the white of the paper for highlights.

• *This exercise reinforces tonal drawing skills and promotes awareness of the tonal range of various grades of graphite found in pencils. The ability to create beautifully rich tonal drawings should be among a good designer's repertoire of techniques. Reminder: A designer who can draw well is a great asset to any design studio.*

Steve DeBeus

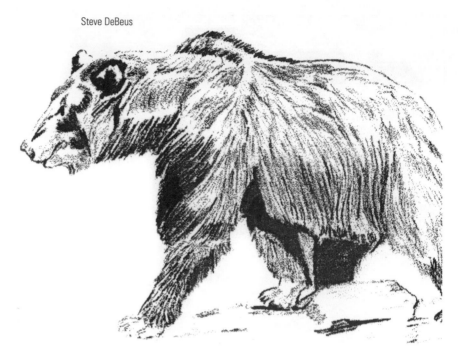

Celine Cahill

Christine Adamcio

8. Limited range

High contrast drawings containing only black and white colors are called upon for many applications: representational illustration, signage, symbols, pictograms, and logos.

It is easy to simplify a photograph or tonal drawing to black and white by reproducing it on a copy machine or scanning it as a bitmap image. Once you've mechanically simplified, you can then individualize the high contrast image by redrawing it yourself and adding your own stylistic interpretations.

Use the tonal drawing you created in a previous exercise or find a photo of your selected subject. Scan or copy it mechanically. Place tracing paper over the reproduction and draw with a black marker those parts of the form you find most interesting and essential.

• *This exercise teaches you to how edit a form for black and white impact.*

Minnie Mester and Bridget Marinaro

9. High contrasts and hand writing

Logos often include both type and image. Combining a graphic with letterforms states the company name as well as communicates an idea. Designing custom letterforms creates a unique identity.

In this exercise, compose your high contrast imagery with handmade letterforms of an equally dramatic graphic style.

• *This exercise has several objectives: to explore the creation of handmade letterforms, to practice the skill of editing a form, and to learn to unify type with image.*

Minnie Mester and Bridget Marinaro

10. Draw with your fingers

Drawing is usually executed with a tool. There is a pencil, or a stick of charcoal, or a pen in your hand which makes the marks on your paper. Your hand is only the guide. In this exercise, you'll eliminate the tool and work directly on the surface with your hands and fingers. You will find that this direct method yields formal characteristics that are wonderfully unique.

For this exercise you will need a good black stamp pad. Using the tips of your fingers and thumb, dab, press, and drag the ink on the paper. Thinking about light and shadow areas, model the form you have selected as your subject. You can use the white of the paper as highlight and create the darker areas by building the density of ink. Okay, you can add line if you must define an edge.

• *This exercise steers you away from the habit of thinking of drawing as form created by a line with a pencil. Using your hand as a tool gives you the opportunity of approaching drawing from a refreshingly direct method.*

Michael A. Gomes

Shana Leigh Acosta

Steve DeBeus

11. Comparative grid

Colors, shapes, and textures are never viewed alone. They are always seen in an interactive composition. Fundamentally, design is the thoughtful interaction of elements composed to communicate ideas. By making comparisons, we analyze and understand the world around us. Comparisons arranged by a designer can generate ideas through provocative juxtapositions.

Using at least five different drawing media and techniques from the previous exercises, compose a grid of your drawing experiments. Juxtapose them to heighten the differences between images. By placing differing images next to one another, you enhance variety and the comparative value of the whole composition.

• *This exercise brings together the various media and techniques for a comparative study. The grid acts as a media and technique "sampler" and can be used as a resource for applications in design. Grids also are a good method of unifying a great variety of styles.*

Shana Leigh Acosta

Shana Leigh Acosta
Drawing Grid

12. Homage to Alberto Giacometti

There are some individual artists and designers who are geniuses. Their vision is so unique as to be a language unto itself. Alberto Giacometti's technique of drawing a continuous line to amass form has an emotionally charged, rugged aesthetic.

In this exercise, create your selected subject or hand-letter type in the drawing style of Giacometti.

• *Emulating a master artist stimulates creative muscle.*

Sherida Martin

Kathy Blake

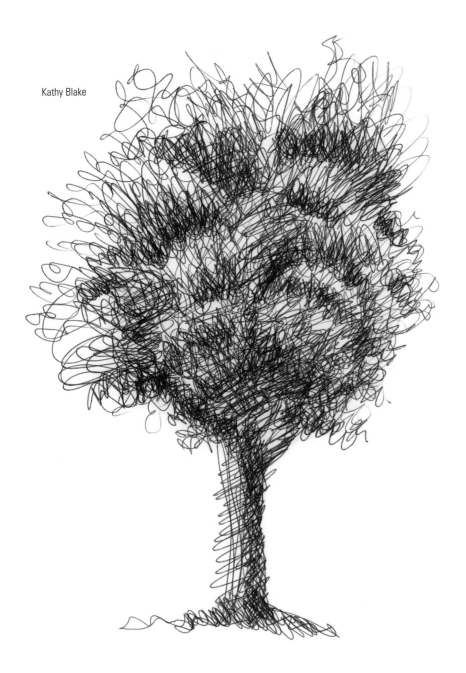

13. Stylized

Throughout history many artists and designers invented original ways of depicting form. Familiar objects would be rendered in a variety of abstractions to communicate ideas, emotions, or simply to present a fresh, new formal variation.

Using your chosen subject, quickly sketch the subject's basic form. Study it. Working from your quick sketch see if you can develop an abstract view of the form.

• *Abstracting or stylizing a familiar form leads to interesting and often dramatic graphic effects.*

STEP 1: Basic sketch of a tree

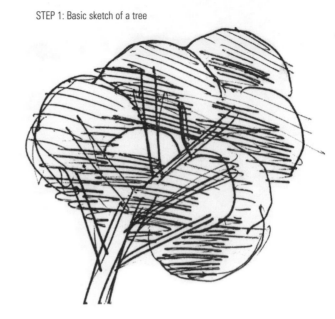

STEP 2: Stylization of sketch

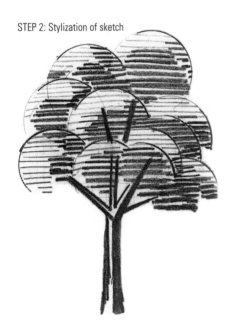

STEP 3: Refined stylization

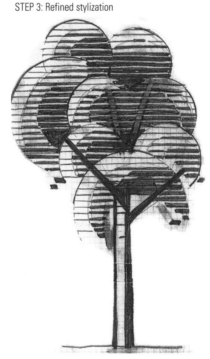

STEP 4: Finished graphic

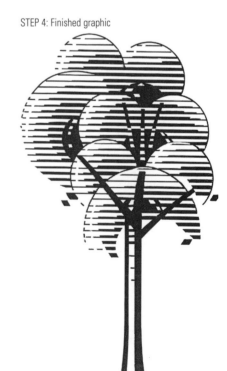

Alternate stylization of a tree
Martin Holloway, Martin Holloway Graphic Design, Warren, NJ

14. Text type collage

Collage can be employed for many design applications including book, magazine, and CD covers, posters, and advertisements. Like a drawing, collage has a personal and deliberately handmade visual appearance. We relate to a collage because we are very pleased by its humble, human qualities.

Gather a pile of black and white text pages from magazines. Tear the pages into a variety of sizes and shapes to build an image. Torn to jagged shapes, text type no longer functions as something to read; type is transformed into a purely visual texture. Good designers will compose type on both a functional and visual level. You can use your selected subject or choose a non-objective design.

• *With this exercise, you practice collage techniques and develop awareness of the visual textures created with black and white text type.*

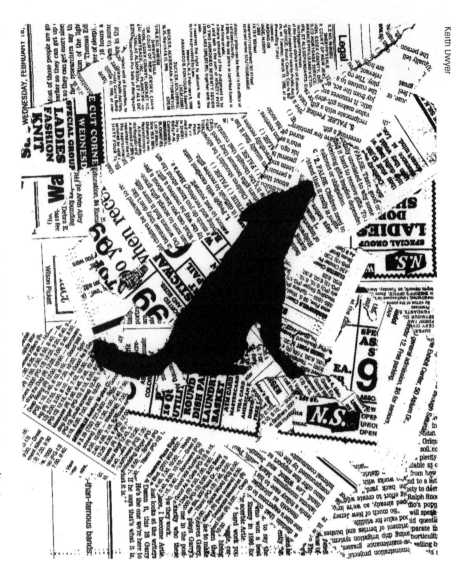

Keith Dwyer

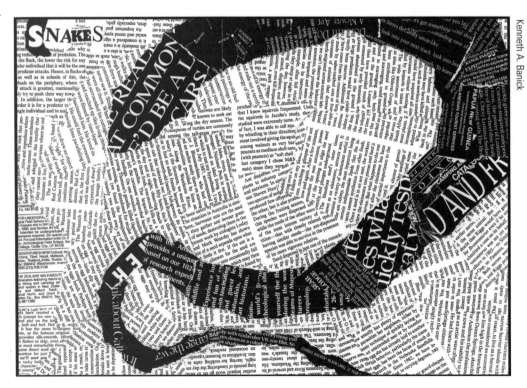

Kenneth A. Banick

15. Image collages

Collage is an expressive and frequently used technique in illustration. Mixing a batch of unrelated images clipped from magazines into a single overall form can have hilarious results. Or, the odd juxtapositions of unrelated images can shock or surprise.

Start by gathering a large group of small images clipped from magazines. Spread the imagery before you. Search for images that will represent the various parts of your selected subject. Look for the oddest or most clever juxtaposition of forms but don't lose the relationship to the original subject.

• *This exercise stretches your ability to make interesting and provocative formal associations. Also, it strengthens your illustration skills.*

Teresa Dus

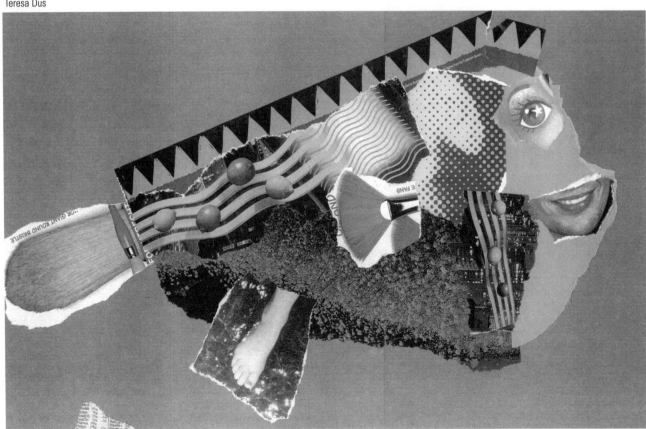

16. Found paper collages

There is a fabulous variety of colored paper and textures available to designers. Paper can be collaged to illustrate ideas or represent form. Paper can add compelling visual texture.

Gather paper in a variety of textures, colors, and opacities. Do not clip from magazines. Instead, gather free samples from paper companies and retail paper stores. Attend a paper show sponsored by your local graphic design club! If your budget allows, purchase some beautiful hand-made papers from your local art supply store. The papers you find might eventually inspire the entire concept for a future design application.

Compose the various papers to represent your selected subject or a nonobjective design. You may choose to add type. Handwrite a bit of incidental text on a piece of white paper. Copy the text onto your paper samples. Add to your composition.

• *Paper is an integral part of the design idea and not merely a background white sheet on which type and images are contained.*

Christine Adamcio

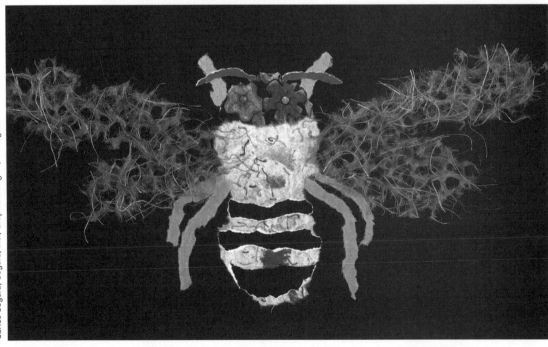

Carlos Segura, Segura, Inc., Graphic Designer, Chicago IL

17. Mixed up media

A collage does not have to be a one-stop technique. Combine media and techniques such as painting and collage or brush and ink images with paper cut-out images. Experimentation leads to wondrous discoveries.

Create a type, image, and textured paper collage using your selected subject as a basis for form. Using acrylics, paint the background areas with a shockingly bright color. Let the acrylic dry. Paint over the background areas with a color that is harmonious. The bright color underpainting complements the overpainting. Now paint over your entire image — that's right, paint it out! Before the paint dries, wipe off the paint from selected areas to reveal the most interesting layers of the collage. You can paint and wipe and scrape away until you reach a satisfying image.

• *Combining techniques stretches your visual vocabulary.*

APPLICATION

Design a poster using unique effects

Designers who choose never to use hand skills in their work severely limit their visual vocabulary and expressive range. To ignore new technologies also narrows expressiveness. It is important to understand that both hand skills and technologies can work together for the benefit of the design.

As a starting point, use the hand-rendered images you have created from previous drawing experiments. Scan the images into a photo-editing computer program such as Adobe Photoshop™. You can choose to crop or scale your images in some way. Once you've edited the individual image, impose one or more of the photo filters or special effects over your drawing. Choose a subject (for example, a cultural festival, a performance, a nonprofit announcement) and poster size. Then print the new images composing them in a comparative grid.

• *This application gives you an opportunity to discover the value of combining computer techniques with hand drawing skills, to increase your visual vocabulary, and to reinforce comparative compositional skills. You will discover that effects you achieve from working with your own drawings are quite different than using photographs.*

3
Visual Surprises

What is a visual surprise?

A visual surprise wakes up our senses. It makes us see something in a new way, makes us take note, or gives us cause to say, "Hey, great visual thinking!"

So much of what is produced is humdrum. A lot of design work looks like a lot of other design work. Often, common-looking work adequately solves the client's communication need — such as giving the client a letterhead or brochure that communicates information. However, the work doesn't distinguish itself from the design glut. Or to use an old advertising phrase, adequate solutions simply "don't break through the clutter." So, when a good designer (and there are many) produces a creative design solution we are often treated to a visual surprise.

How do you create a visual surprise?

Certainly, the first step is to avoid allowing people to yawn in reaction to your design — to avoid hackneyed images and conventionalized ideas; shun played-out concepts, visuals, and headlines. Look for fresh, unique, stunning ways of seeing.

You're cordially invited to the Vistakon Vision Expo East Cocktail Party at the New York Hilton on Friday, March 7, from 5-8 pm. RSVP to Diana Krier (904) 443-1347

It's definitely not business as usual

▶ Figure 3-1
Title: New York Olive Invite
Studio: St. John & Partners, Jacksonville, FL
Art direction: Jefferson Rall
Design: Jefferson Rall / Dawn Annunziata
Writer: Shannon Strickland
Print Producer: Marcia Karol
Client: VISTAKON
This poster invitation was developed for a cocktail party in New York that would be held during an industrywide distributor's conference for Vistakon, contact lens manufacturers. The client wanted a memorable piece. "A cool cocktail party in New York that shouldn't be missed," — that's what we wanted to get across.

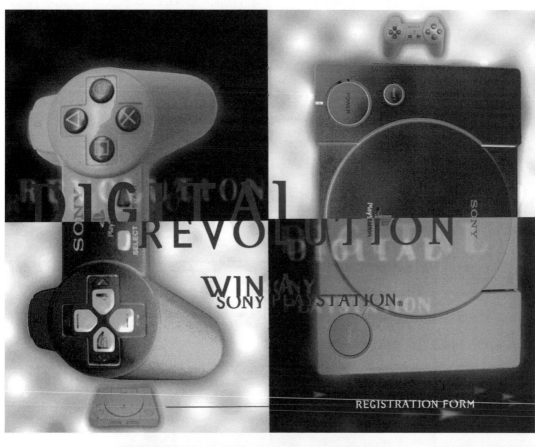

◄ Figure 3-2
Title: *Primed for Life*
source guide
Studio: St. John &
Partners, Jacksonville, FL
Art direction: Jefferson
Rall/Rob Semos
Design: Jefferson
Rall/Rob Semos
Client:
SONY and PRIMCO

We wanted the book to
sell the new launch of the
store without being too
commercialized. We had
to speak to the college
market in a design style
that was youthful, fun,
and hip, without being too
trendy.

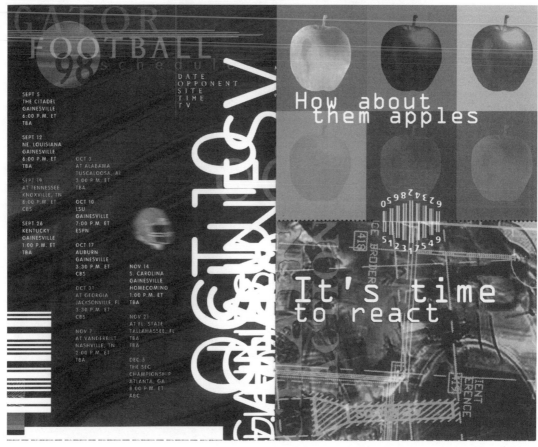

How do you know what is worn-out?

- Simple — you've seen it before, perhaps several times or

- You've heard it (headline copy) before

- The visual is overused, for example, the Statue of Liberty or Michaelan- gelo's *God and Adam* on the Sistine Chapel ceiling

- It's a cliché, like a happy face or rainbow

- It's corny or mawkishly sentimental (without being purposely caustic), like Elvis on velvet or a big-eyed, sad clown

- It's boring. It smacks of unremitting sameness, or it lacks variety

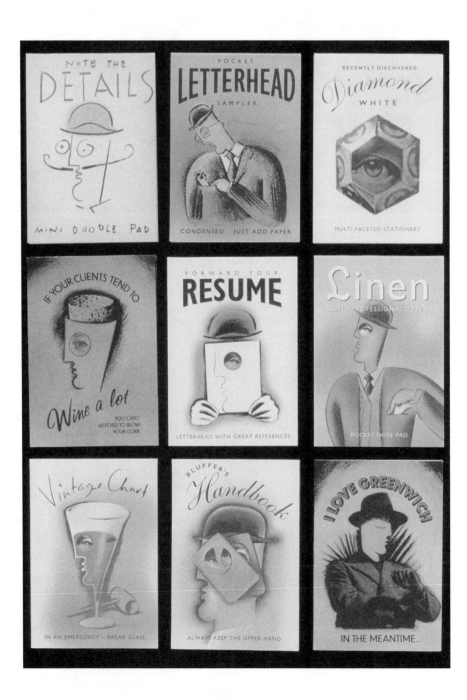

▶ Figure 3-3
Title: Conqueror pocket cards & mini-notepads
Studio: Viva Dolan Communications and Design Inc., Toronto, Canada
Designer: Frank Viva
Writer: Doug Dolan
Illustrator: Frank Viva
Printer: Annan and Sons
Client: Conqueror Fine Papers
British and French posters from the 1930s inspired the look of this promotion for Conqueror papers. Because the papers are similar to many North American fine papers, we chose to empha- size their different qualities — their British ori- gins — through the illustration style and the recurring figure of the man in the bowler hat. As well, the cards are designed to be "functional" — wine vintage guides, time zone charts, mini- notepads, and so on — to ensure they'll be kept and used.

What is fresh

There are tons of visual surprises created by wonderfully witty designers, art directors, illustrators, and photographers. We've chosen a few categories of visual surprises to help you find ways to delight the viewer:

- Unexpected visuals

A visual surprise isn't the expected — it's the unexpected. There are an infinite number of ways to create a visual surprise. You can create an unexpected visual by manipulating an image, using language as a jump start, or ghosting an image. Designer Jefferson Rall's imagery on this poster/invitation is a visual treat (figure 3-1).

- Contrasts and combinations

Some people say to do something creative you take two old things and combine them into one new thing. If the same old thing is the only thing available, combine it with another and make one great new thing.

Others say: contrast things — emphasize differences by setting in opposition. Big contrasts also can cause surprises. Emphasize differences by looking for fantastic juxtapositions, or setting a strong opposition, which despite the contrast remains unified, for example, Jefferson Rall's imagery for these pages of a promotional brochure (figure 3-2).

- Where have I seen that before?

Use or borrow elements or motifs from the other arts and architecture to create new visuals. For example, Viva Dolan's pocket cards and mini-notepads (figure 3-3).

- What a Great Idea!

Coming up with a completely fresh idea that is unusual, breaks ground, reinvents a product, service, package, identity, or just about anything. Here are four very different examples of great visual surprises: The type on Carlos Segura's business card is made with metal, light and cast shadow (figure 3-4), Liska's super cropped imagery on these pages for Pricewaterhouse Coopers mortgage banking brochure (figure 3-5), Vrontikis Design Office's all occasion "to:from:" gift tags made from unique tree-free alternative papers (figure 3-6), and Russell Hassell's use of a die cut in this cover for "Team Spirit" (figure 3-7).

◀ Figure 3-4
Title: Segura Business Card
Studio: Segura Inc., Chicago, IL
Creative direction: Carlos Segura
Design: Carlos Segura
Client: Segura Inc.

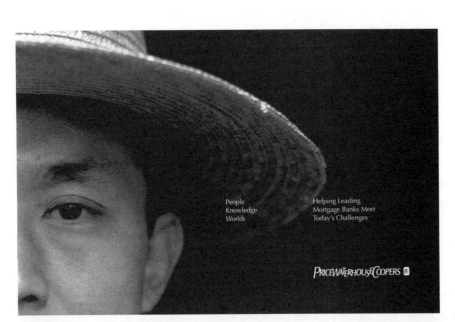

▼ Figure 3-5

Title: PricewaterhouseCoopers
mortgage banking brochure
Studio: Liska + Associates, Inc., Chicago/New York
Design: Susanna Barrett
Printing: Phototype Color Graphics
Client: PricewaterhouseCoopers

PricewaterhouseCoopers asked Liska + Associates to design a promotional handout for the annual New York Mortgage Bankers' Convention. We recommended producing a brochure to highlight the consulting services and experience that PwC offers banks in the mortgage market. The result was a small, eight-page piece with promotional potential that extends beyond use at this convention. The versatile piece was produced within the original budget for a single sheet. Because we transformed it into a general marketing piece, PwC is able to use the brochure for other events.

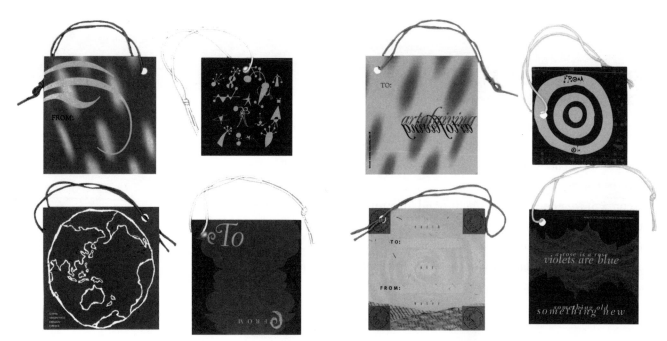

▲ Figure 3-6
Title: Unique tree-free all occasion gift tags to:from
Studio: Vrontikis Design Office, Los Angeles, CA
Creative direction: Petrula Vrontikis
Client: Vrontikis Design Office

▲ Figure 3-7
Title: *Team Spirit,* exhibition catalogue
Studio: Russell Hassell, New York, NY
Design: Russell Hassell
Client: Independent Curators Incorporated, New York, NY

EXERCISES

Unexpected Visuals

1. Create a visual metaphor or simile

Some of the greatest advertisements and posters are visual metaphors. Rather than hitting someone over the head with a visual of the product or event, an art director may choose to seduce the viewer with a related or a totally unexpected (unrelated) image.

Represent roughness (which might stand for a rough beard) or a cool sensation (which might stand for a peppermint candy) using a visual metaphor. You can represent anything of your choosing.

• *Learning to think metaphorically broadens your creative repertoire, yielding wonderfully captivating results.*

Betty Erder

Betty Erder

2. Create variations of a visual or object

Very often, a slight alteration will make a visual or object seem novel and appealing.

Take one image or object and manipulate it — play with it — until you have three variations on the original. A variation may be a change in color, texture, position, etc. It might be an addition to the object or subtractive.

• *Sometimes all it takes is a slight variation to create an entirely new visual and that's the message of this exercise — to give something visual punch.*

Rosemary Bavosa

Minnie Mester

3. Take something opaque and make it appear transparent

Software makes it very easy to create special effects. However, a designer must fully understand the impact each effect has on the viewer and how effects work in combination and alone. Ghosting an image can give an eerie look or an atmospheric one; it depends on how you do it.

Take something opaque and make it appear transparent; ghost it or make it look like it has been x-rayed.

• *The point of this is to fully understand the visual impact of a special effect.*

Alex Yee

Alvaro Montagna, Graphic designer, NJ

APPLICATION

Design an alphabet (English or any other language) based on a particular object or image

Font design can be fun. Type can be derived from or based on imagery.

Design any alphabet and base it on a particular image or object. For example, design caps based on legs with kneecaps as the joints of the letters!

• *Becoming more aware that type is shape and seeking alphabet-like shapes within other forms are the goals of this exercise.*

Contrasts and Combinations

4. Juxtapose newspaper imagery against original photographic prints

Juxtaposing different or opposite imagery yields powerful results, for example, lace and rusted metal. A designer can juxtapose all types of visuals.

Contrast a black and white image that you find in a newspaper (images which have been screened for reproduction) by placing it next to original black and white photographs you have taken.

• *The point of this exercise is to set off dissimilar surface qualities.*

Larry Coffin, Computer graphics professional, Nantucket, MA

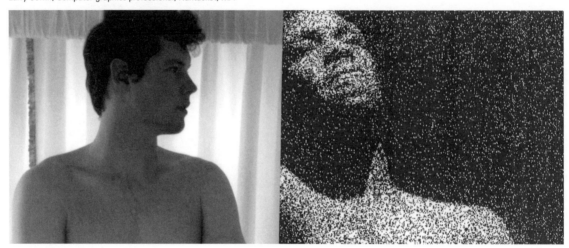

5. Combine two images or objects into a new whole image or object

Designers, illustrators, and advertising art directors always need a range of visuals to express different ideas and communicate different messages.

Fully integrate — merge — two (related or unrelated) images or objects.

• Finding imagery that can stop someone in their tracks gets more and more difficult. Merges can make new wholes, be provocative, and provide markedly refreshing results.

Bridget Marinaro, "The Official Fruit of Baseball"

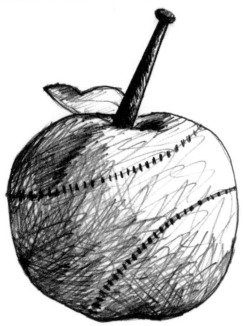

Katie Tanaka, "X-Acto Rose"

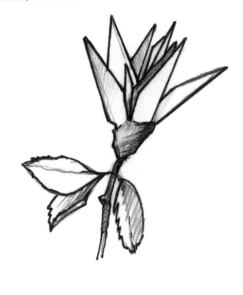

6. Juxtapose images whose subject matter is opposite in emotion, texture, or some other quality

Juxtaposing different or opposite imagery yields powerful results. Imagine a chocolate bar next to a cement block. Imagine whipped cream with a cherry on top juxtaposed to a porcupine with a pink nose. Imagine a desert landscape next to an image of a cold and rainy cityscape. A designer can juxtapose all types of visuals.

Juxtapose images whose subject matter is opposite in emotion, texture, or some other quality.

• *The purpose of this exercise is to create understanding through visual comparison of opposites. We know a tree is tall because we compare it to our own height. We help others understand the world better when we make comparative analyses.*

Dawn Pittaro

Michael A. Gomes

APPLICATION

Create an appointment/date book for college students by combining handwriting and photographs or illustrations

It's very difficult to design a typeface. On the other hand, you may not want to use an existing font for your design. The obvious and wonderful choice is using your handwriting (when appropriate to the project, of course).

Choose a college or university and design an appointment book cover; the appointment book would be offered for sale as a promotional item in the college bookstore. Combine handwriting with the chosen visuals. Fully integrate the handwritten letters into the shapes of the illustrative or photographic imagery.

• *This application has two major goals: (1) selecting type or lettering that is both appropriate for the visual and the message; and (2) learning to compose so the type and image are symbiotic.*

Where have I seen that before?

7. Design untraditional wedding cake statuettes

We've all seen the traditional bride and groom atop a wedding cake. Yawn!

Rethink the traditional wedding cake statuettes or figures and create an expressive variation. You could have a theme, use scale, imagery, or a style that dispossesses the traditional one. Your design could make people laugh and exclaim, "Oh, my!" or be clever enough to make people say, "How interesting!" It's up to you.

• *The point of this exercise is to make us see a customary form anew, to recast something familiar into an exciting, fresh appearance.*

James Burns, Industrial Designer, NYC

Laura Ferguson Menza, Graphic Designer, NJ

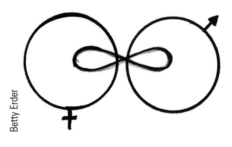
Betty Erder

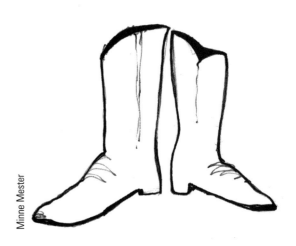
Minne Mester

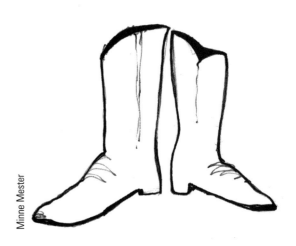

8. Alter an existing well-known sign, logo, or package

Logos are ubiquitous in American pop culture and carry either status, brand quality, or brand spirit. The average consumer has a huge visual vocabulary which includes logos, both old and new.

Take a well-known sign, logo, or package and make it your own. Alter it in some way to make it exclusively yours and so that the alteration considerably changes the sign's, logo's, or package's message, spirit, or appearance.

• *The point of this exercise is to learn that making a slight adjustment can re-create or reinvent a visual and make everyone take another look.*

Gloria Rose

Betty Erder

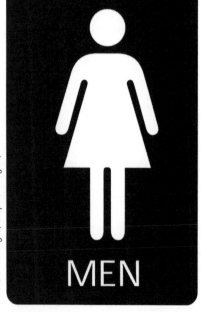

Alvaro Montagna, Graphic Designer, NJ

9. Using architectural motifs from a foreign country, choose lettering that complements the architectural style

Other arts, such as architecture, tapestry, or pottery, are wonderful visuals that are often overlooked as sources for design inspiration. Visuals pulled from things we've seen in foreign settings or places (either in person, in a book, or on film) can stir feelings, conjure up a mini travel adventure, or appeal to our sense of touch and sight in new and exciting ways.

Using architectural motifs from a foreign country, choose lettering that complements the architectural style.

• *This exercise has two main objectives: (1) learning to choose appropriate type for visual style; and (2) learning to appropriately incorporate other visual arts into graphic design and search out stimulating visuals. Realizing that type has structure and particular form, just like architecture, is of paramount importance to the graphic design novice.*

David Lawson

Teresa Dus

David Lawson

APPLICATION

Design a birth announcement for yourself

Perhaps your parents sent out a birth announcement for you. Well... now you're a fully grown you with a fully formed personality.

Redesign your birth announcement (or if you didn't have one, create one), to reflect the fully fledged you. Hindsight is a wonderful thing!

• *This application is both meant to expose you to experimentation with conventional formats and to teach the importance of reflecting a distinctive personality through a design.*

Christine Adamcio

What a great idea!

10. Design rural and urban visuals

Gloria Rose, Mailboxes

The urban landscapes of most major cities, whether they are cities like New York, Tokyo, or Buenos Aires, are intensely littered with commercial imagery, such as signage (both print and neon), outdoor boards, posters, and bills posted on walls and poles. The urban landscape is its own animal — a unique loud visual poem, unlike a bucolic landscape or a small town landscape.

Design a composition, for example, a poster, or a three-dimensional object (for instance, street light or traffic sign) that would fit into a rural setting and one that could compete or fit into an urban landscape of a particular city. Think about type as having a voice (a loud one) and a tone (the particular tone of the chosen city). Choose visuals and color that would stand out among the city clutter while still being appropriate for an urban landscape.

• *The point of this exercise is to analyze a setting and design for it — know where it will be seen/experienced. Also, to learn to create something that will merit attention in the din of an urban environment and not disrupt the quiet of a rural landscape while still attracting attention is another goal.*

James Burns, Industrial Designer, NYC, Birdfeeder attaches to tree or pole

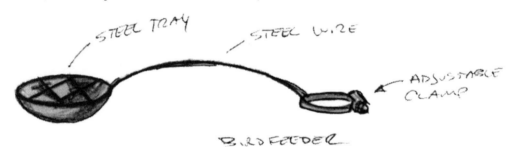

Joseph Konopka, Graphic Designer, NJ, Fire Hydrants for the Country and the City — one nostagic and the other industrial sleek

11. Design an individual package for a pineapple

Of course pineapples aren't packaged, but wouldn't it be interesting if they were — and had to compete for attention on the supermarket's shelves? Being ecologically minded, we wouldn't want to create a package for something that didn't need one, nor would we encourage it; this is just a fun exercise. Unless, of course, we could create a package that could be reused over and over again; for example, a cloth bag that could be reused by the consumer.

Design an individual package for a pineapple. The sketches for this exercise may be either two-dimensional or three-dimensional. (Three-dimensional sketches can be created with paper and glue, clay, cardboard, or even a kneaded eraser!)

• *The challenge of this exercise is to open your mind to designing just about anything — even a serious design for a quirky three-dimensional form. This exercise allows you to have fun with packaging. You should research packaging materials.*

Mary Degnan

James Burns, Industrial Designer, NYC

PINEAPPLE PACKAGE

Joseph Konopka, Graphic Designer, NJ

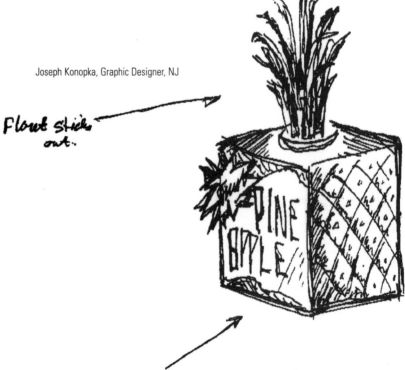

Flower sticks out.

PINE APPLE

Base gets packaged in box cardboard or plastic.

12. Redesign a backpack to communicate the personality of a celebrity

Backpacks have little personality. Some are more stylish than others. Some are purely designed for function; and some are decorated with commercial cartoon imagery. With time and use, some backpacks begin to take on the character of their respective owners, just as worn shoes or jeans do.

Redesign a backpack to communicate the personality of a celebrity.

• *The point of this exercise is to give an inanimate object personality. It prepares you to give spirit to a client's logo or mark.*

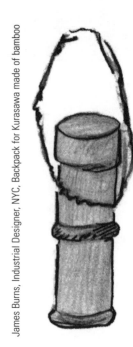

James Burns, Industrial Designer, NYC, Backpack for Kurasawa made of bamboo

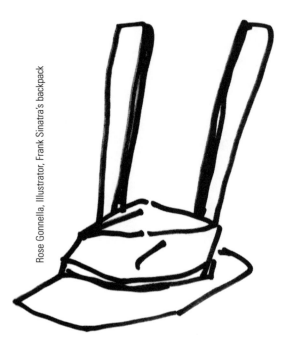

Rose Gonnella, Illustrator, Frank Sinatra's backpack

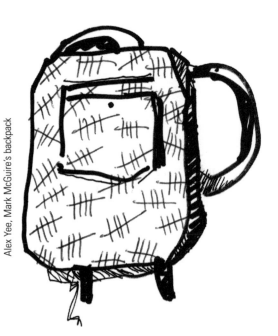

Alex Yee, Mark McGuire's backpack

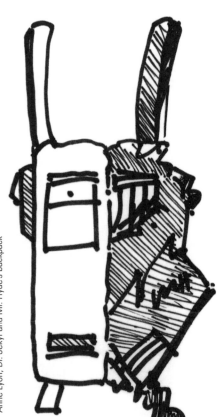

Anne Lyon, Dr. Jekyl and Mr. Hyde's backpack

13. Communicate your personality through a pattern on a necktie

Widths of neckties come in and out of vogue. So do necktie patterns. One can tell a lot about a person by examining the necktie he (or she) chooses to wear.

Using pattern and shape, design a necktie, bandanna, or cap to communicate your personality.

• *Design is about communication; and it's important to explore the ways in which pattern and shape can communicate meaning or spirit.*

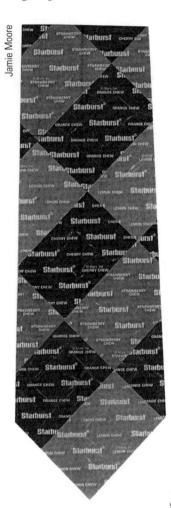

Jamie Moore

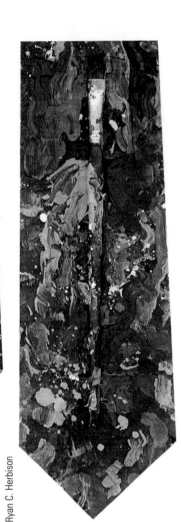

Ryan C. Herbison

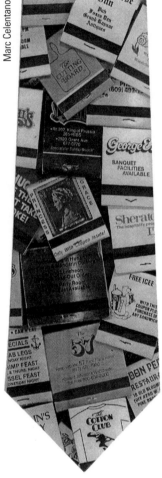

Marc Celentano

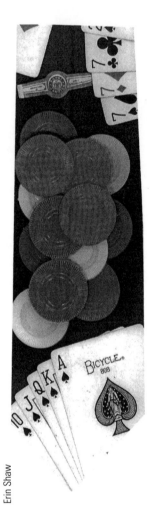

Erin Shaw

APPLICATION

Design an abstract visual for a snowboard.
Have the visual connote the illusion of dynamic movement.

Graphic design is omnipresent; every surface seems to be designed. A snowboard is a wonderful format that can be thought of as a blank canvas. It has a unique shape and purpose.

Using dynamic form, line, and color, design an abstract or representational visual for a snowboard. You can broaden this assignment by designing a series of related images, which would establish an identity for a special edition line of snowboards.

• *Learning to design a visual that is both appropriate for a product and is attractive to the product's audience are vital visual thinking skills.*

chapter

4
Points of Departure

What is a point of departure?

You are confronted with a design problem. With any number of avenues to take, where do you begin? Often, a client or the nature of a project itself imposes limits on you. There are times when you can begin anywhere or with anything — when you have total freedom. That's when you need a platform, a means for expression, a point of departure for the design message.

▼ ▶ Figure 4-1
Title: *Now is our time,* brochure
Studio: Concrete, Chicago, IL
Design: Jilly Simons & Anna Suh
Client: IIDA/International Interior Design
Association

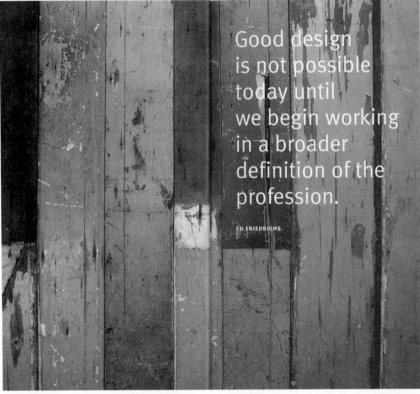

Good design is not possible today until we begin working in a broader definition of the profession.

ED FRIEDRICHS

We are in the business of designing human relations. We design situations, not spaces.

RICHARD FARSON

Good listening leads to understanding.

CARL FERENCE

Every great design must contain within it a balance of memory and possibility. We want the technological power of the new in the guise of the familiar.

PAUL GOLDBERGER

PART TWO THE WORKOUT

Many designers choose themes, style, or found imagery as their points of departure. Each of these can be the starting point from which your concept evolves. Think of these points of departure as the vehicle that will take you where you want to go. You can find one by thinking of a new course of action.

How do you know when to use a point of departure?

- The client wants a theme
- You have a style the client admires and that works for the project
- You've found imagery that would express your concept

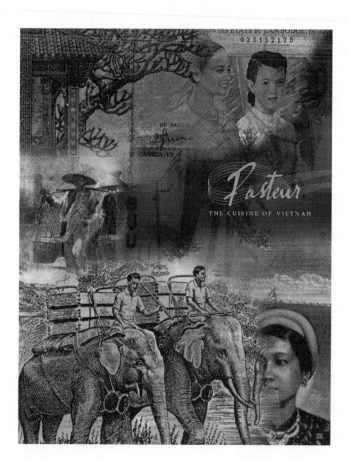

Themes

With a universe of information available and so much to know and understand, a theme points to one place — it creates a central focus from which ideas can radiate.

If the theme is a subject or topic like fishing, you include the topic itself and all things related to the topic such as gear, the fish, and places to fish. Or a theme is an implicit or recurrent idea or motif; for example, chocolate or water.

Themes are often utilized for serial projects, such as a series of book jackets, CD covers, or posters. Corporate identities, promotional pieces, and advertisements also can utilize themes, as in Concrete's brochure "now is our time" (figure 4-1), which employs weather beaten surfaces as a visual theme throughout the book.

Found imagery

Not all visuals have to be original. There is a history of utilizing found materials and visuals in art and design. Why not draw upon the available wealth of visuals to be found in the world?

It's certainly a way to start. Take a look at Carlos Segura's identity design for Pasteur (figure 4-2).

◀ Figure 4-2

Title: Identity items for Pasteur Vietnamese Restaurant/menu cover

Studio: Segura Inc., Chicago, IL

Creative direction: Carlos Segura

Art direction/design: Colin Metcalf

Client: Pasteur Vietnamese Restaurant

EXERCISES

Themes

1. Design water

Often a design piece has a theme, whether it's a paper promotion or an annual report. A theme, an implicit or recurrent idea, may be a visual one, a motif, or a topic. A water motif is a good one because it's general, suggests color and movement, and could appeal to the tactile sense. Water has been designed in a number of ways, though many designs rely on a cliché wave to depict water.

Try to come up with new ways to depict water; please don't use any clichés in this exercise.

• *The point of this exercise is to learn to establish a theme and come up with new ways to visualize cliché images, like water.*

Cesar Rubin

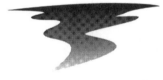

Stacy L. Bober

2. Use near and far vision

When something is cropped it implies that the object is near to you. When something is in full view, the implication is that you are far enough away from it to see it in its entirety.

Using the relationship of near and far vision, crop images of airplanes and show airplanes in full. Execute this on a grid (of equal or unequal units). You may go from near to far, far to near, or mix up the order.

• *The point of this exercise is to learn the dynamics of cropped vs. full view imagery as it relates to our vision. And to understand that one object (your theme) can look like many when viewed from a variety of angles.*

Layla Reino

Celine Cahill

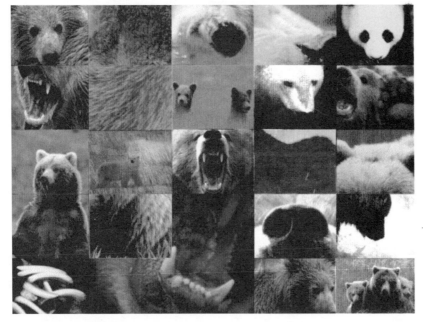

Steve DeBeus

APPLICATION
Reflect the zeitgeist

The visual and performing arts cross over and are interconnected. The arts reflect the world at large and the times.

Design a playbill or poster for a play or performance that responds to or reflects the zeitgeist — the spirit of our times. Both the play and the design should reflect the zeitgeist.

• *There are two major points to be gained from this application. One goal is to understand that there are trends and ideas in any given period. Another goal is to learn that imagery and type can reflect the zeitgeist.*

Found imagery

3. Create a cachet for a first day of issue stamp

There are enough stamp collectors among us to prove people's love affair with stamp imagery.

Create a cachet. Envelopes stamped with a postmark that indicates the first day a new stamp is placed on sale is a first day cover. First Day cancellations are usually accompanied by a decorated envelope — the "cachet." Choose a stamp you find interesting or provocative and create an image in response to it; design a cachet.

• *Discovering how to react to a given visual is the point of this exercise. Often designers must work with given visuals of varying quality, to create a design piece.*

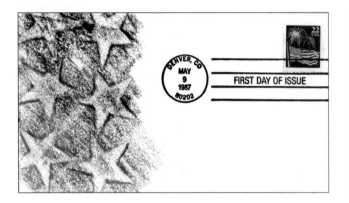

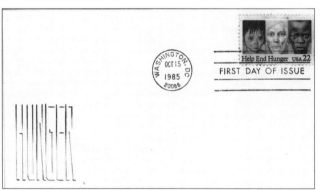

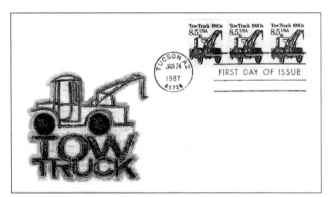

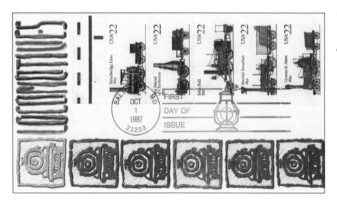

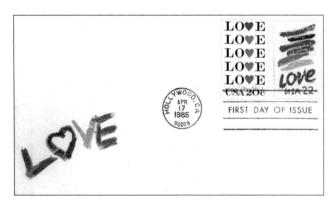

Tony Ciccolella, Art director, AARP Creative Services, Washington DC

4. Replace parts of a vintage postcard

Many designers find inspiration in images and styles of the past. Time-worn cigar-box lettering or orange-crate labels have been known to inspire some famous contemporary designers.

Find a vintage postcard at a flea market or vintage store. Replace parts of the imagery to create a fresh, startling, or unusual visual.

• *The point of this exercise is to learn to take something old and make it new again; to learn to rethink a visual, to reinvent an old image. Recasting something old into a different configuration can yield a fresh visual.*

Celine Cahill

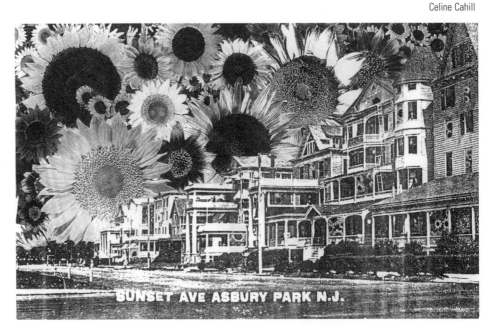

Robert Fennimore

5. Draw with found objects

Images created from something completely different than traditional media can astonish or amuse. Add a great deal of visual surprise to your designs by employing unexpected media and techniques.

Instead of using pens, pencils, or brushes to draw, or papers to create a collage, create an image using small common objects (or not so common ones). You can create your image directly on the workbook page, or on the surface of a copy machine and adhere the resulting image to the workbook page.

• *This exercise not only increases your visual muscle, it also reminds you that in art and design almost anything can be used to expand creativity.*

APPLICATION

Design a resealable coffee package

Inspiration comes from the world around us, including ephemera.

Find a vintage postcard, label, cigar box, or fruit-crate. Use the style of the vintage piece as a point of departure for a soft, resealable coffee package. Also, invent a name for the coffee to agree with the visual style.

• *The point of this application is to learn to draw on every available visual source for inspiration.*

Staci Bacsoka

Kelli Rodriguez

Keith Dwyer

chapter

5
Work It Out

Why you need to work it out

When we say, "work it out," we mean two things: a graphic designer's creative workout and problem solving — figuring out solutions to a wide variety of graphic design problems. The following group of exercises require a variety of skills, both hand/eye skills and critical thinking skills.

Graphic designers need to be well-rounded, well-educated, highly informed professionals who are adept at a variety of communication skills and thinking skills. These exercises are sure to hone your proficiencies.

Which skills are important to this workout?

- The ability to ideate — to think visually
- Visualizing skills, like drawing and sketching, both perceptually and conceptually
- The ability to analyze
- Understanding a context
- Being able to reduce something to its most elemental visual components

Picture this

Before the computer, software programs, and scanners were a graphic designer's main tools, virtually all designers could draw and sketch very well. Though not an absolute necessity, the ability to draw and sketch is still an

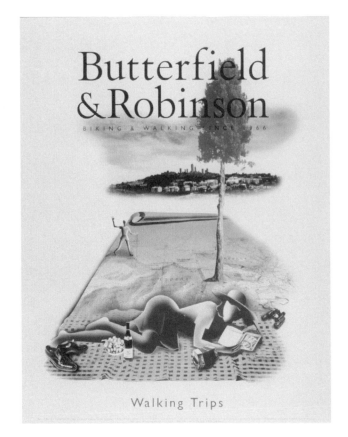

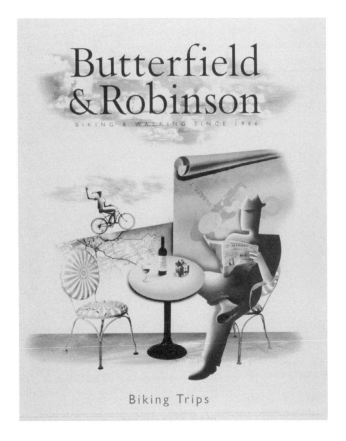

▶ Figure 5-1
Title: Butterfield and Robinson posters
Studio: Viva Dolan Communications and Design, Inc., Toronto, Canada
Design: Frank Viva
Illustration: Frank Viva
Client: Butterfield and Robinson
Butterfield and Robinson is an upscale travel company specializing in biking and walking trips to Europe and around the world. In this promotion they wished to convey the romance and relaxation of travel in order to counteract the perception that these trips are for athletes.

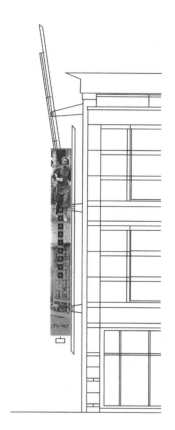

incredible asset. These exercises will give your hands and eyes the workout they probably crave. Designer Frank Viva possesses extraordinary drawing skills as evidenced in these posters for Butterfield and Robinson Walking and Biking Trips (figure 5-1).

Environment:
Where will it be seen?

If the piece you are designing will be seen on the side of a truck you will have different considerations than if it will be seen on a website, a matchbook, or a calendar. Some graphic design is intimate — we hold it in our hands. Other graphic design is big, bold, and even goes on the side of a moving vehicle. Where and how something will be seen is an important consideration.

Ema Design's blade sign and banners for Maggiano's corner bakery are fine examples of graphic design that complements architecture and is meant to be seen from a distance (figure 5-2). Not only can the blade sign and banners be seen and read, but they express an old-world feeling about a neighborhood business (they also look "delicious," if that's possible.)

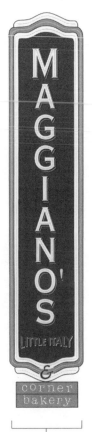

3' 11" 15"

▲ ◀ Figure 5-2
Title: Maggiano's Little Italy and Corner Bakery blade sign, banners, and Corner Bakery entrance sign
Studio: Ema Design Inc., Denver, CO
Art direction: Thomas C. Ema
Design: Thomas C. Ema
Client: Maggiano's Corner Bakery
The design goal of this series of signs was to reflect the two restaurants' identities, Maggiano's Little Italy and Corner Bakery, within the design guidelines of the retail and entertainment center, Denver Pavilions. First, we designed the 20-foot tall blade sign using neon open channel letters and encompassing an overall shape that recalls signs of the 1940s. All the while we paid special attention to the size, scale, and placement of the sign to the architecture and style of the building. The banners were designed to fit predetermined sizes and mounting structures. We incorporated the restaurants' logos and utilized old black and white photos from the restaurants' archives to evoke a 1940s sense of place and time. The Corner Bakery entrance sign was designed to fit around an existing canopy. The sign features interior lit letters and small footlights washing up from the arched front.

Chapter 5 Work It Out

129

Logos, pictograms, icons, symbols, and signs

Some people say that designing logos is the meat and potatoes of the visual communications business. If it is not that, it certainly is a central part of graphic design. And along with pictograms, icons, symbols, and signs, on some level, logo design asks the designer to capture, symbolize, and express meaning in a singular visual. What a challenge!

For example, designer Petrula Vrontikis' logo for MAMA Records utilizes the graphic contrast of the black and white piano keys as a strong, memorable visual (figure 5-3). A variety of symbols are used in graphic design, just compare the different visual styles of illustrator, Jim Dryden's delightfully playful horoscopes and Russell Hassell's inventive symbol for his book jacket design for After Perestroika (figures 5-4 and 5-5).

The last stretch in any workout is always the toughest. You have pushed your muscles and now you are asking them to do more.

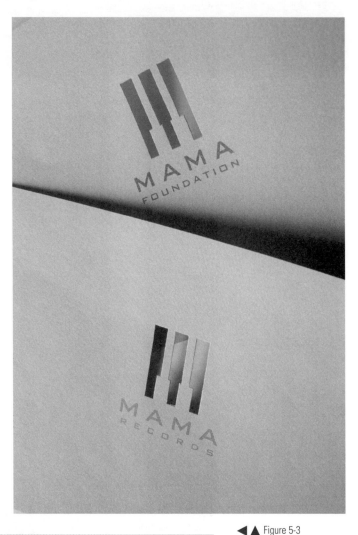

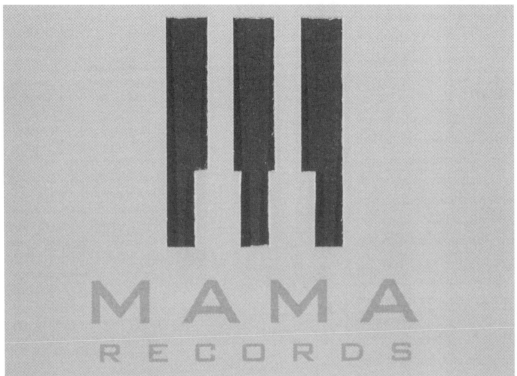

◀▲ Figure 5-3
Title: MAMA Records logo
Studio: Vrontikis Design
Office, Los Angeles, CA
Art direction: Petrula
Vrontikis
Design: Kim Sage
Client: MAMA Records
MAMA Records and the
MAMA Foundation are
devoted exclusively to jazz
artists. The criteria to keep
the identity clever, simple,
and timeless resulted in this
logo design, which is die-cut
out of the top of the letter-
head. It is an economical
use of one-color printing on
a series of colored papers.
The die-cut logo image is an
unexpected surprise.

▼ Figure 5-4
Title: "Love Mates" zodiac symbols
Studio: K-Tell International, Plymouth, MN
Art direction: Linda Stanke
Illustration: Jim Dryden, Falon Heights, MN
Client: Audio Scope

▼ Figure 5-5
Title: *After Perestroika: Kitchenmaids or Stateswomen,* exhibition catalogue
Studio: Russell Hassell, New York, NY
Design: Russell Hassell
Client: Independent Curators Incorporated, New York, NY

After Perestroika: Kitchenmaids or Stateswomen was a traveling exhibition of works by contemporary Russian artists concerned with feminist issues. When people ask me where I get my ideas, I sometimes quote my wife who responds, "He gets into bed and says, 'I have this project… what should I do?'" I was naturally drawn to the former flag of the Soviet Union, but I credit my wife with the interpretation of the hammer and sickle as a frying pan and spatula. The glossy red cover stock with yellow opaque foil stamp completes the flag reference. To emulate the feeling of the Cyrillic alphabet in English words, I set lowercase Es at uppercase height. I resisted reversing the Rs — it just didn't look right to me.

Chapter 5 Work It Out

EXERCISES

Picture this

1. Make a shoe anthropomorphic

People love to attribute human characteristics to inanimate objects. Here's your chance.

Give a shoe human characteristics.

• *Often aspiring designers will simply tack human features onto an inanimate object. It takes more thought to successfully anthropormorphize an object, turning it into a viable illustration.*

Robert Fennimore

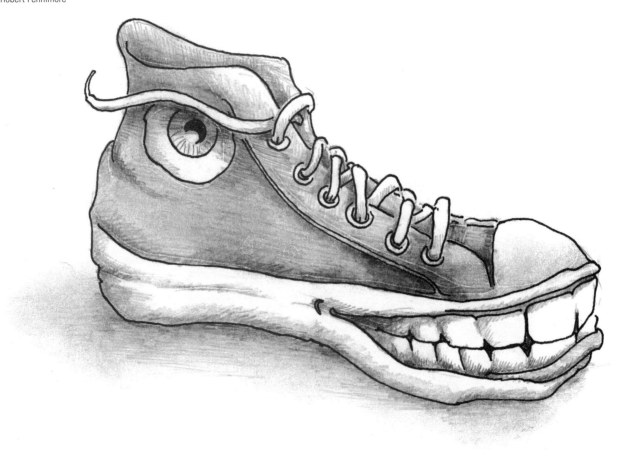

2. Draw something in motion

Movement is illusive and artists have made various attempts to capture it on a two-dimensional surface. Illusion is surprising because we do not expect it.

Draw something in motion, for example, a person dancing, walking, or exercising, a motorcycle whizzing by, or a walking dog.

• *Creating the illusion of movement on a two-dimensional surface can be an effective way to capture people's attention.*

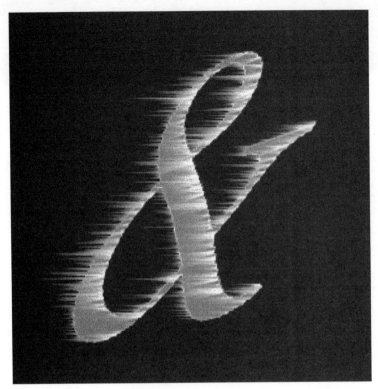

Staci Bacsoka

Robert Fennimore

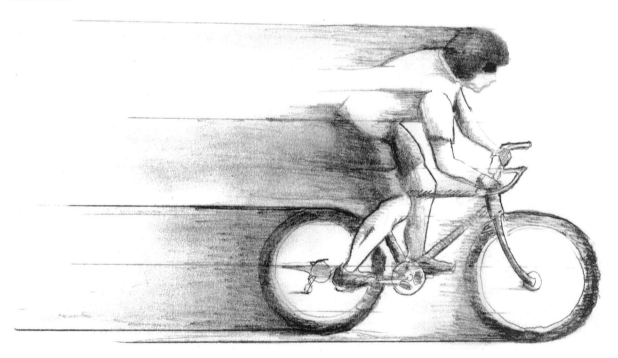

3. Draw yourself by looking down your body

Novices tend to draw everything straight on and centered on the page. Rarely do they think of using atypical points of view.

Either sitting or standing, draw yourself by looking down your body. Remember to be conscious of foreshortening. Draw what you see, not what you know to be.

• *Atypical points of view can startle and tickle the viewer's imagination.*

Robert Fennimore

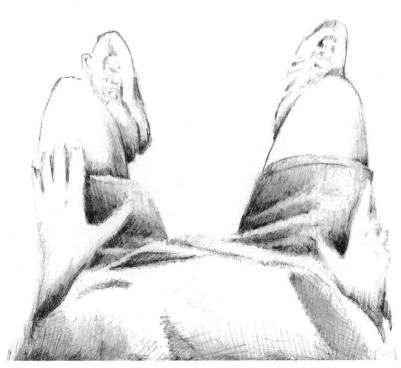

Rose Gonnella

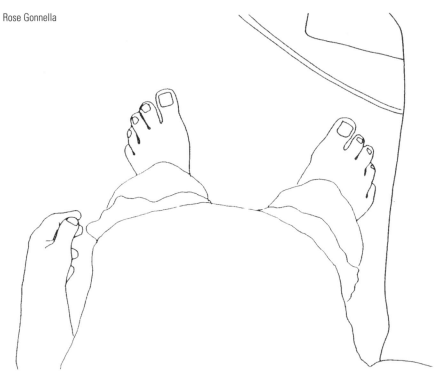

4. Draw a musical sound

For many people, especially those involved in the visual arts, it is almost impossible to listen to music without imagining images. Sound has "color," rhythm, emotion, style, personality.

Draw a high contrast image of a musical instrument; abstract its form to represent the sound that the instrument creates.

• *Designers and illustrators are often called upon to invent images for abstract ideas, emotions, and even sounds.*

Steve DeBeus

Lynn T. Wu, "Flure di Flute"

Kenneth A. Banick

Staci Bacsoka

APPLICATION

Design three jelly labels

Very often, the focal point of labels is a visual. Using illustration as a focal point, design a set of three labels for homestyle jam or jellies.

The illustrations should be rendered in a similar fashion, in the same style. For example, if one illustration is linear, they all should be linear. The type should be appropriate for the visuals.

• *The point of this is to establish a visual relationship of color, form, and style within the series.*

Environment: Where will it be seen?

5. Water tower design

Your local water tower rises above the average home or office. It can be seen from a distance, the highway, or a high-rise window. Usually, it carries no more than the water utility's logo on its surface.

Design a graphic for a water tower.

• *Learning to design graphics that can be seen from a distance, whether on a truck or bus, outdoor board, or poster, is part of a graphic designer's training.*

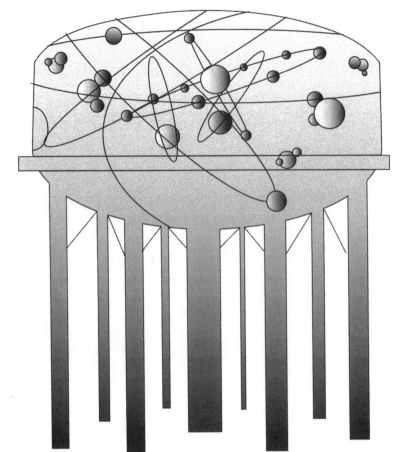

Robert Fennimore

Stuart Topper, Artist and designer, Metuchen, New Jersey

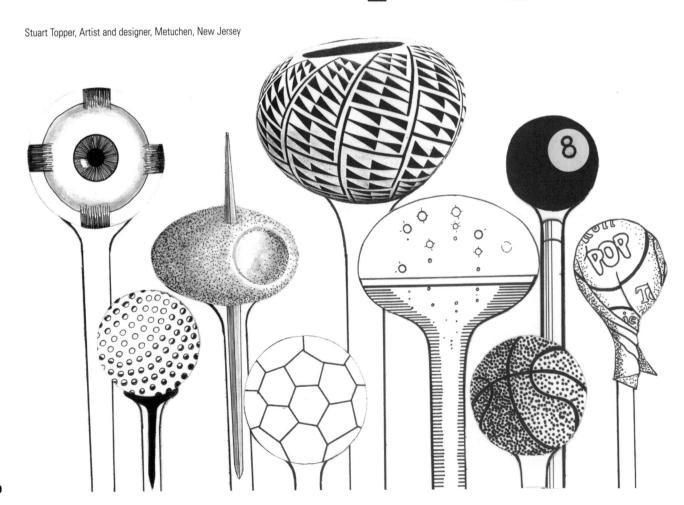

6. Party hat

Whether it's a child's birthday party or New Year's Eve, many of us will wear a party hat to add to the good spirit of the celebration. Party hats and costumes are often used to signify a specific occasion. Costumes (including hats) and theme parties allow participants to morph into any personality they choose. It is a chance to act out your inner-self.

Design a party hat that would make you the life of the party.

• *The point of this exercise is to create a piece that will break through the visual clutter of a crowd.*

Luther Gibbs III

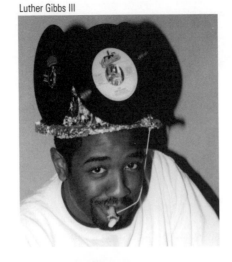

Jocelyn Poslusny

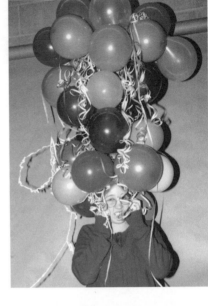

Seth Goodwin

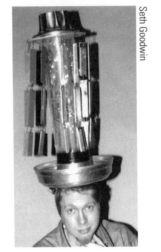

Shana Leigh Acosta

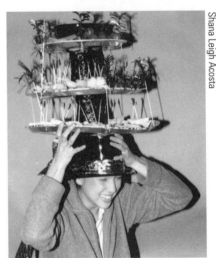

Ryan C. Herbison

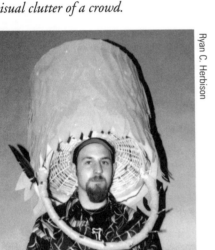

Marc Celentano

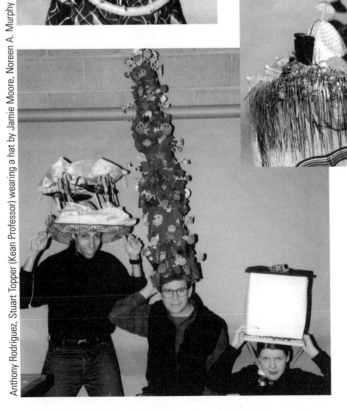

Left to Right: Nicole Maron, Erin Shaw, Jason D'Angelis

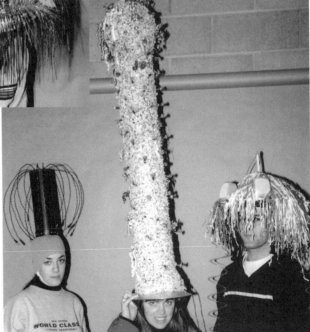

7. Design a tattoo

Tattoos go in and out of vogue. Some people use them as markers, some as status, some to show they belong to a group or gang, some use them to reveal something about themselves. Tattoos may be illustrative or graphic.

Design a tattoo to reveal your personality. Graphic design is ubiquitous — it even appears on bodies. Creating graphics that can be worn illustrates that any surface can hold a graphic design or illustration.

• *A note on designing tattoos from Mickey Ricci, professional tattoo artist, at Laughing Buddha Tattoo Studio in Seattle, Washington: "There are certain approaches to keep in mind that are specific to tattooing. For instance, there are no borders to a tattoo. The design creates its own boundaries in relation to where it sits on the body. Strong design and a sense of flow is important. Skin is a unique canvas and is always changing."*

Mickey Ricci, Professional tattoo artist, Seattle, WA

APPLICATION

Design signage and
floor motifs for a toy store

Toy stores are fun places for toddlers, children, and, yes, even adults.

• *Using flat colors and exciting shapes design signage and floor motifs for a toy store. This allows you to create a design project for a specific audience and to ensure that it is appropriate for its surroundings. Here's a great opportunity to do some amusing research, like visiting a great toy store.*

Logos, pictograms, icons, symbols, and signs

8. Take an image down to its most elemental

How do you know which bathroom door to open? The pictogram on the door informs you as to which gender utilizes the facility. Those bathroom pictograms distinguish men from women by hair shape and clothing shape.

Find or take a photograph. Take the photograph down to its most elemental forms.

• *A pictogram is the visual essence of a thing or person. When creating a pictogram, deciding which forms to keep and which to delete is both a valuable and necessary learning process.*

Stacy Bober

Anthony Rodriguez

Betty Erder and Bridget Marinaro

9. Draw objects in the same technique

Successful pictogram systems or sign systems depict the pictograms or signs utilizing the same graphic or illustrative technique. Using the same technique establishes unity among the parts integrating them into a whole, larger system.

Choose a few objects, such as tools, cooking utensils, or just about anything, and draw or design them in the same technique. In other words, if you use line, you must use a linear technique on all of them. If you use a woodcut style, you must use it consistently.

• *Learning to establish unity within a system is very important.*

Jim Dryden, Illustrator, Falon Heights, MN

10. Design a symbol that means equal but opposite

The Yin and Yang symbol is well-known; very generally, it symbolizes the cosmic principle in Chinese dualistic philosophy of equal opposites. The forms of the Yin and Yang are equal and opposite. A symbol represents something else by association, agreement, or likeness.

Design a symbol that means equal but opposite. Keep positive and negative shape relationships in mind.

• *The symbols in different cultures and countries are universal. Symbols can be extremely powerful communication and carry great connotation, used in such domains as religion, biology, mathematics, meteorology, pharmacology, and so on. Think of the meaning that the Cross carries in Christianity or the male and female symbols in biology. The point of this exercise is to learn to create a graphic design solution that carries potent meaning.*

Robin Landa

Gloria Rose

Minnie Mester

Chris Matina

11. Design signs for weather, emotions, or household chores

Signage is all over our environment — road signs, street signs, store signs. Most signs belong to a system created for a particular city, company, or purpose; the sign system will employ the same typography or shaped graphic imagery.

Design four signs to represent either the weather, emotions, or household chores.

• *Learning to create a system of forms and/or typography is an essential graphic design skill.*

Lynn T. Wu

Julie Schroder

APPLICATION

Create five related pictograms for a website

Websites rely on imagery for both decoration and information.

Using only a single weight line, create five related pictograms for a website. Since the World Wide Web is international, it is crucial to utilize visuals that can be universally interpreted and understood.

• *Creating visuals that can communicate without language is a necessary skill for a graphic designer to possess.*

DMA

Steven Brower Design

Tony Ciccolella

Donovan and Green

Jim Dryden Illustration

Ema Design, Inc.

Russell Hassell

Martin Holloway Graphic Design

Liska + Associates, Inc.

Tom Payne

point **b** incorporated

Jefferson Rall

Segura, Inc.

Mary Ann Smith Design and Illustration

Stuart Topper

Viva Dolan Communications & Design

Vrontikis Design Office

!deaWorks

DMA

Denise M. Anderson
DMA, Jersey City, NJ

◀ Title: Sandler Capital Management
Corporate capabilities kit
Design studio: DMA, Jersey City, NJ
Art director: Denise M. Anderson
Designers: Laura Ferguson, Denise M. Anderson
Illustrator: Mary Flock
Client: Sandler Capital Management
Sandler specializes in three main areas of investment management: Media, Entertainment ,and Communications. DMA created a puzzle concept where elements of these sections come together to form a whole. With the assistance of Mary Flock's woodcut illustrations, we were able to create a look that was a little less "traditional corporate."

▶ Title: Art Directors' Club of New Jersey identity system
Design studio: DMA, Jersey City, NJ
Art director: Denise M. Anderson
Designers: Laura Ferguson, Jenny Calderon, Katherine Schlesinger
Client: Art Directors Club of NJ
As newly elected President of the ADCNJ, one of the first orders of business was to create new collateral material for the Club. Using the newly designed logo from former President Alan Gorman, DMA was able to create an identity system of membership and promotional materials that would update the look of the organization.
— Denise M. Anderson, President
Art Directors' Club of New Jersey

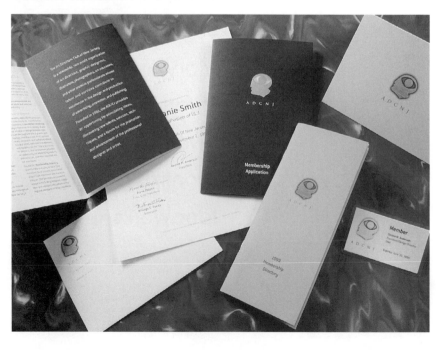

156

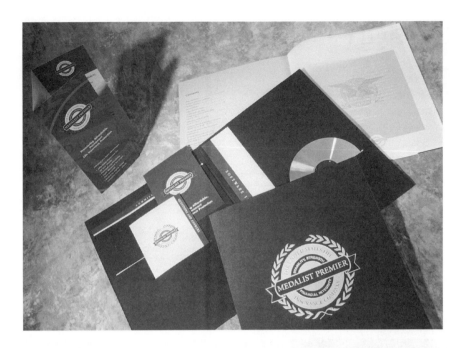

Title: U.S. Life Insurance Company Medalist
Premier program kit
Design studio: DMA, Jersey City, NJ
Art director: Denise M. Anderson
Designers: Laura Ferguson, Katherine Schlesinger,
Denise M. Anderson
Client: U.S. Life Insurance Company
U.S. Life Insurance Company had a line of insurance
products called Medalist Premier. DMA's mission
was to create a kit with all the information needed
to explain the program to brokers and to create
solicitation material targeted toward the end users.

Title: ITC Ad campaign / promotional material
Design studio: DMA, Jersey City, NJ
Art director: Denise M. Anderson
Designers: Jenny Calderon, Denise M. Anderson
Client: International Typeface Corporation
ITC asked DMA to first create an ad campaign that was far less
busy than the four-color articles and ads in their publication,
U&lc. We designed double-page ads in only black and red colors
with a right hand page with only the web address on it. In addi-
tion, we created promotional postcards in the same style as the
ads.

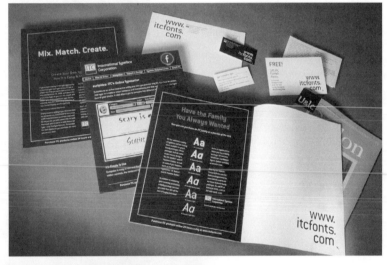

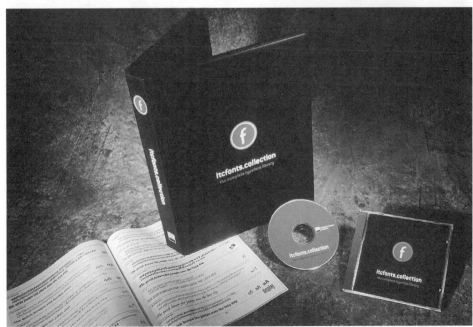

Title: *itcfonts.collection* typeface kit
Design studio: DMA, Jersey City, NJ
Art director: Denise M. Anderson
Designers: Jenny Calderon/Denise M.
Anderson
Client: International Typeface
Corporation
DMA needed to design a kit to house a
CD-ROM and a catalog of over 1,000
ITC fonts titled: *itcfonts.collection*.
We picked up the minimal black and red
design style of the ad campaign to
make all of ITC's materials different, yet
cohesive. The plastic and vinyl holder
with a 1½" spine gave the program
shelf life presence.

Denise M. Anderson

Steven Brower Design

Steven Brower
Steven Brower Design, New York, NY
Steven Brower is art director for *Print Magazine*. He is the recipient of numerous national and international awards, and his work is in the permanent collection of Cooper-Hewitt National Design Museum, Smithsonian Institute. He is on the faculty of the School of Visual Arts, New York and Marywood University's Masters with the Masters program in Scranton, Pennsylvania. He was born and raised in Manhattan and the Bronx, and attended the High School of Music and Art and the School of Visual Arts. He resides in New Jersey with his wife and daughter and their dog, birds, and mice.

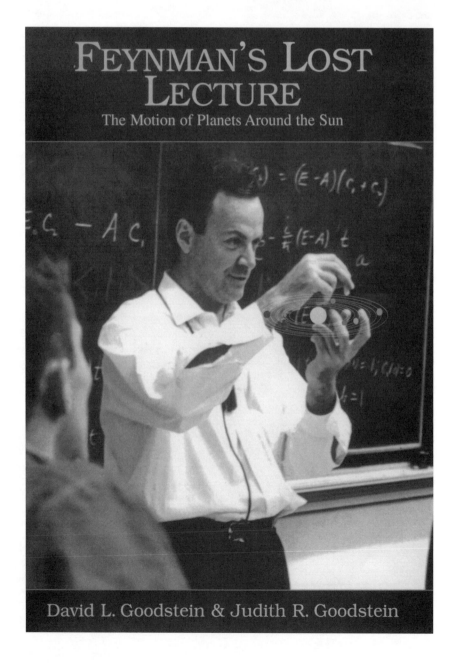

▶ Title: Bookjacket for *Feynman's Lost*
Design studio: Steven Brower Design, New York, NY
Design: Steven Brower
Client: W.W. Norton
Cover for a book on the scientist's famous lost speech.

▲ Title: "The Nose No.2," front cover
Design studio: Steven Brower Design, New York, NY
Design: Steven Brower
Client: The Pushpin Group
Publication that interprets the written or spoken word.

▼ Title: "The Nose No.2," spread
Design studio: Steven Brower Design, New York, NY
Design: Steven Brower
Client: The Pushpin Group
Publication that interprets the written or spoken word. In this
piece, Senator Huey Long's 1945 "Every Man's a King" speech.

Steven Brower Design

LANGUAGE ON THE FRINGE

▲ Title: *Oxymoron Vol. 2*, "The Fringe" issue
Design studio: Steven Brower Design, New York, NY
Design: Steven Brower
Client: Oxymoron, Inc.
Opening spread for "Language on the Fringe," an article about how speech develops.

▶ Title: Bookcover for *Edward R. Murrow*
Design studio: Steven Brower Design, New York, NY
Design: Steven Brower
Photography: Photofest
Client: Da Capo Press
Book about the famous early newscaster. The cover is appropriately black and white.

▼ Title: *Oxymoron Vol. 2*, "The Fringe" issue; Beat
Design studio: Steven Brower Design, New York, NY
Design: Steven Brower
Client: Oxymoron, Inc.
Opening spread for an article about the beat generation.

Tony Ciccolella

Tony Ciccolella
Art director, AARP Creative Group, Washington, D.C.

I began creating cachets for First Day Covers in 1984, partly because I wanted to see if I could do it, partly because I got too cheap to buy them.

I was a stamp collector as a kid, and part of my collection was first-day covers, envelopes stamped with a postmark that indicated the first day a new stamp was placed on sale. First Day cancellations are usually accompanied by a decorated envelope — the "cachet." I had been purchasing the cachets from commercial vendors and thought I could do just as well on my own.

Using a silver marker, I created my first cover for the 1984 Alaska Statehood stamp, a simple type treatment of the word "Alaska" with the crossbars in the "A's" removed to represent a mountain range. Simple, it worked for me. I made ten copies and began my "hobby."

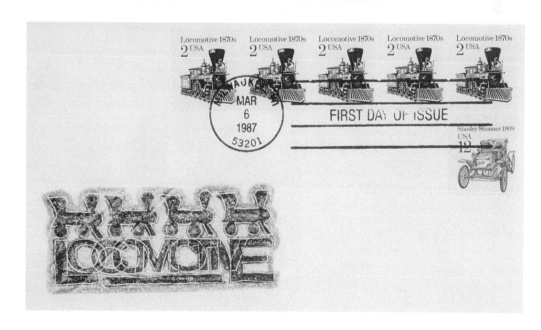

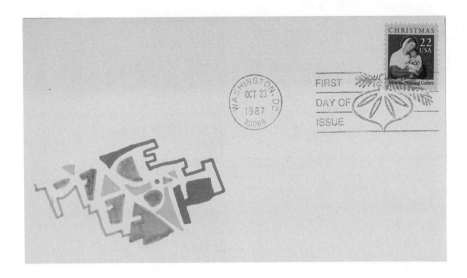

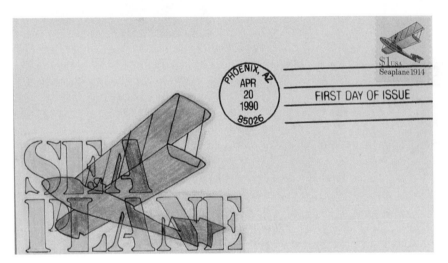

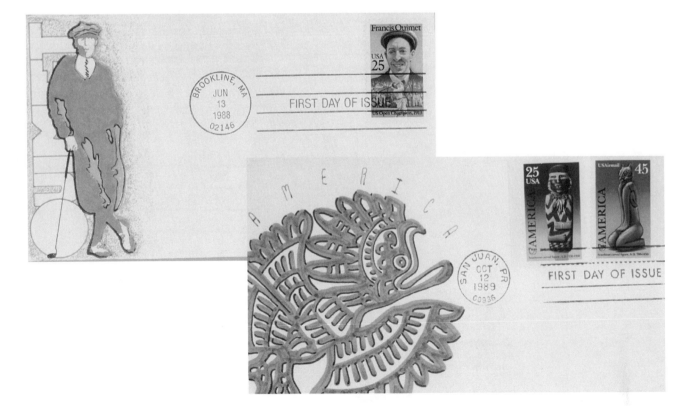

Later on, I joined the American First Day Cover Society and began selling my extra copies by mail order and at their annual conventions. I had many regular customers, as well as a couple of dealers who purchased a few of everything I created.

Creating these cachets helped me decide to return to college to complete the degree work I had dropped out of a few years earlier. When I put together a presentation of my accumulated cachet work for the Art Directors Club of New Jersey, it helped me earn a $1000 student scholarship, a great help in getting that degree work completed.

For me, it was my first experience at creating graphic design, playing with type and color and layout and concept. It actually became my first portfolio, before I had enough student and freelance work to show. The first time I showed my envelopes at an

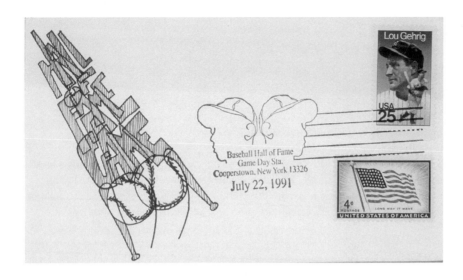

Art Directors Club portfolio review, it wasn't considered "serious graphic design." However, a friend who worked at an ad agency let me show them to her Creative Director, who through them, saw that I could think and conceptualize, and gave me my first freelance assignment. They have always been part of my design portfolio. People are always curious and surprised about them, not the kind of stuff you usually see in a designer's portfolio.

These first day covers represent personal work that has meant a lot to me over the years. It was work that I did to please myself first, it was work that I believed in regardless of who did or didn't, it was work that allowed me to play and explore and learn about design, and it was work that helped build my career as a designer. Not bad for a bunch of silly little envelopes.

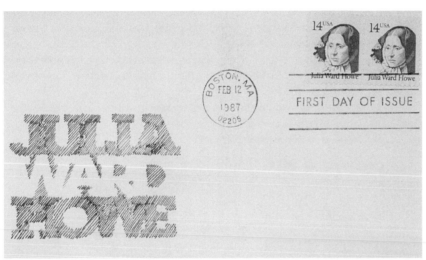

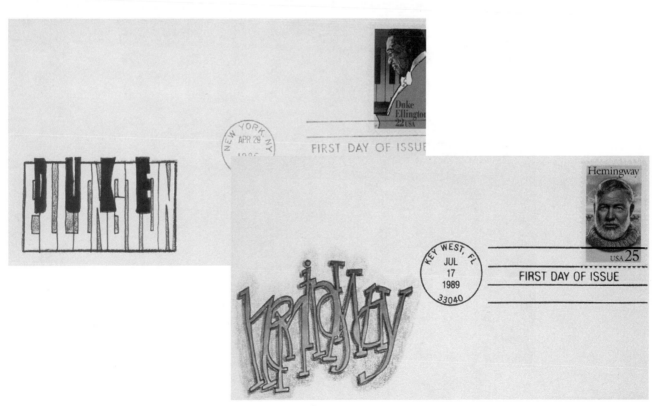

Tony Ciccolella

Donovan and Green

New York, NY

▼ Title: Ronald Reagan Presidential Library
Studio: Donovan and Green, New York, NY
Project principals: Michael Donovan, Nancye Green, Susan Berman, Stuart Silver, Susan Myers
Client: Ronald Reagan Presidential Library

Some would say that a presidential library is the ultimate exercise in Making the Complex Clear; others would say it's simply impossible. In fact, it's a little of both. Documenting any presidency isn't solely about official papers: it's about capturing the essence of a man and his beliefs — or at least as much as possible. Clearly, this was our challenge in designing the 22,000 square feet of public exhibition space for the Ronald Reagan Presidential Library in Simi Valley, California.

The museum traces his life from boyhood through the presidency. But the "story" is more than where he came from and what he did; it's about what he became over the years, and why, and how that affected his political party, his fellow countrymen, and the world.

Every president ultimately addresses a diverse audience, and our task was to make certain that we told a consistently clear story. Information was layered to bring the messages of The Great Communicator to the many different kinds of people who might visit the library on a given day — professors and school children, senior citizens and international tourists, Americans and immigrants, dignitaries and dissidents, men and women from all walks of life. Each person sees in Ronald Reagan something different: leadership, compassion, humor, strength, bravado.

We wanted visitors to leave with more than a set of disconnected, albeit interesting experiences. We wanted to give them access to larger ideas, using and interrelating interactive and dynamic material with static materials. Our goal was to entertain so that we could inform.

To that end, the museum was divided into a series of galleries, each to show part of the Reagan story: The Early Years Gallery combines memorabilia and photographs of his life through the Hollywood days. The Prosperity Gallery uses photographs, quotes, and charts to show how Reagan's policies affected inflation, taxes, and jobs. In the Peace and Freedom Gallery, a timeline displays material from his eight-year presidency.

This museum had to have the man himself in it. An interactive video theater allows visitors to Meet the President, using touch-sensitive monitors to choose questions for him to answer. Not every question deals with the serious business of leading the Western World: There's a humor category, so that his famous jokes — and his inimitable delivery — are not lost.

An exhibit like this must be many things — bold and intelligent, tasteful and dignified, and of extremely good quality. However, Ronald Reagan also enjoyed widespread personal appeal. Therefore the environment, while technologically sophisticated, was designed to be warm, comfortable, and very "human." The road from Dixon, Illinois to the Oval Office — and beyond — is long and complex. But clearly, it's a great story.

▶ Title: Hoffman-LaRoche Ltd.
Studio: Donovan and Green, New York, NY
Project principals: Nancye Green and Marge Levin
Photography: Austin Hughes
Client: Hoffman-LaRoche Ltd.
A knowledge-sharing structure for pharmaceutical development.

The Roche Expert System was created as a means of sharing information across scientific disciplines and of opening conversations among the participants in the drug development process at Roche. Initially the project was focused on gathering the content and creating the structure, tools, and formats for the print documents that comprised the first version of the system. Donovan and Green is also delivering an on-line version of the Expert System via the Roche intranet.

The development of the system called for both navigational and communications tools — multiple indices, time lines for Roche specific decision points, and cross-functional links to vital data. The end result is more than a new way of learning, sharing, and communicating; it represents a fundamental change in how knowledge is shared and therefore how work gets done.

To keep the project refreshed and the participants involved, there are response forms, surveys, and a Team newsletter that is available in print and on-line.

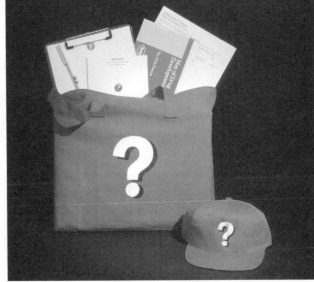

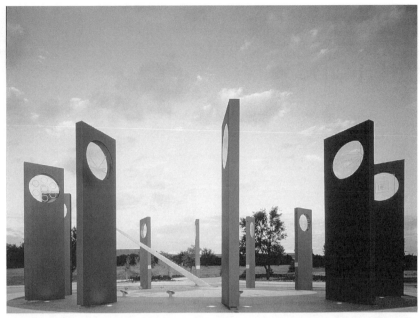

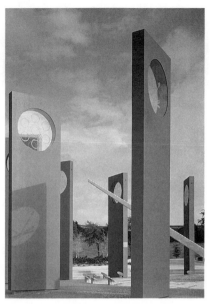

View of angled gnomon

Gnomon shadow casting onto world map surface with time markers

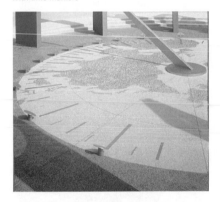

Nighttime view of sundial installation

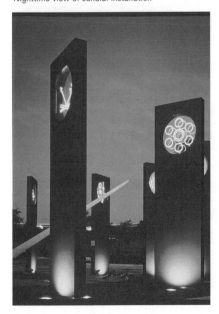

▲ Title: World Wide Headquarters Entry, sundial
Studio: Donovan and Green, New York, NY
Project principals: Michael Donovan and Adrian Levin
Photography: Nick Merrick, Hedrich Blessing
Client: Texas Instruments

Donovan and Green began its partnership with Texas Instruments (TI) by developing a strategy to transform its facilities into communications vehicles. "Information environments" were created to convey key messages about TI's technology and capabilities. The first of these was implemented at the Semi-Conductor (SC) Group's Forest Lane facility in Dallas.

As a symbolic entry to the Forest Lane, one of the largest, most precise solar clocks in the world was conceived and designed by Donovan and Green. The sundial, with a solar projection of the world map at its center, serves as a reminder of TI's global presence, and of its commitment to reduce time to market. The twelve surrounding plinths represent TI's key technological developments while the shadow-casting gnomon points to the celestial pole.

The gnomon is inclined at an angle exactly matching the 32.79° north latitude of Dallas, Texas. At the center, an illuminated Texas Star embedded in the map at Dallas' location is precisely aligned with true north. By standing or sitting at this spot on a clear night, observers can follow the gnomon's length upward with their eyes and see that it points directly toward Polaris, the North Star.

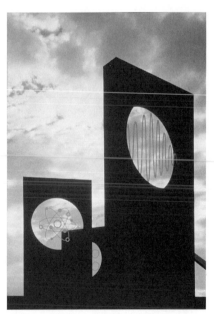

Detail of plinth icons — day

Donovan and Green

Jim Dryden Illustration

Jim Dryden
Jim Dryden Illustration, Falon Heights, MN

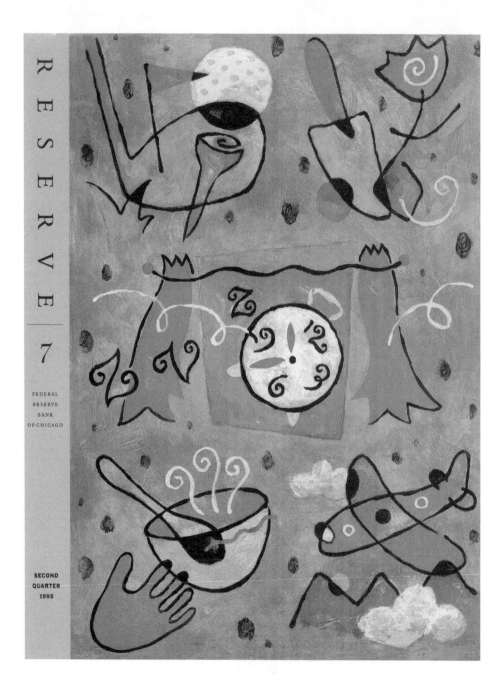

▶ Title: Federal Reserve Bank of Chicago
Quarterly magazine
Studio: Concrete, Chicago, IL
Art direction: Jilly Simons
Illustration: Jim Dryden
Client: Federal Reserve Bank of Chicago

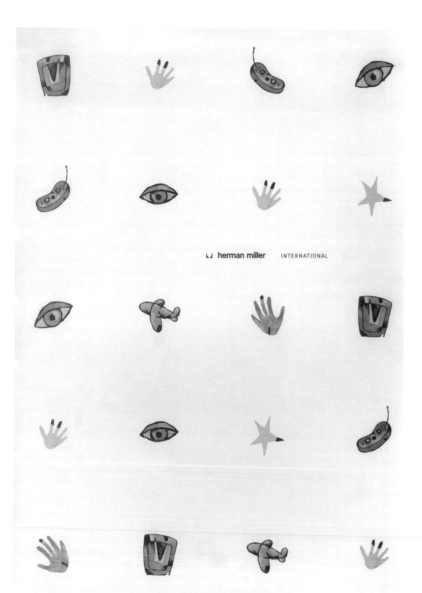

◄ Title: Herman Miller International brochure
Studio: BBK Studio, Inc., Grand Rapids, MN
Principal: Yang Kim
Illustration: Jim Dryden
Client: Herman Miller International

herman miller INTERNATIONAL

Title: Covenant House Lifeline Award Dinner
Dance, 10th Anniversary Celebration, invitation
Studio: Torrisi Design Associates, Inc.,
New York, NY
Art direction: Laura Torrisi
Design: Elissa Birke
Illustration: Jim Dryden
Client: The New York Real Estate and
Construction Industries
Covenant House wanted to commission an original
piece of art to commemorate the tenth anniversary
of this special fund-raising event. A Brazilian Mardi
Gras theme was the inspiration for the illustration
done by Jim Dryden. The peace dove, the symbol for
Covenant House, was also incorporated into the art-
work.

Jim Dryden Illustration

▶ Title: 30th Big Gig
Studio: Hughes, Ruch and Murphy, Brookfield, WI
Creative direction: Dave Murphy
Art direction: Lynn Schoenecker
Writer: Sandy DerHovsepian
Illustration: Jim Dryden
Client: Milwaukee World Festivals, Inc.

◀ Title: Music illustration
Illustration: Jim Dryden
Client: McPhail Center for the Arts

▼ Title: Promotional imagery
Illustration: Jim Dryden

Ema Design, Inc.

Thomas C. Ema

Ema Design Inc., Denver, CO

Thomas Ema develops design solutions that reflect his philosophy of balanced contrasts: "You have to listen to your client's need with one ear. With the other ear, you have to listen to your heart." Yet Ema's design style — rich with understated passion — is far from traditional. Look closely and you will see visual statements that strike a graceful balance between extremes: soothing textural patterns sheathed by hard-edged structural elements; large, bold type softened by italics; gloss and dull varnishes that transform two dimensions into three. "Having grown up in Williamsburg, Virginia, I have a deep appreciation for history and enduring quality," states Ema. Perhaps this explains why his work is imbued with a sense of timelessness that transcends trends and fads. Ema's childhood ardor for painting watercolor landscapes of the Blue Ridge Mountains found its sharp focus at the Kansas City Art Institute, where he studied Bauhaus design. He has said that he knew his schooling was complete when he "learned to paint with type."

▼ Title: Teatro Hotel invitation

Design studio: Ema Design Inc., Denver, CO

Design: Thomas C. Ema, Prisca Kolkowski

Client: Teatro Hotel

This invitation was designed for this unique historic renovation hotel, Teatro. The design is intended to reflect the eloquence, class, and style of the first-class boutique hotel. To achieve this effect, we chose traditional gray Garamond 3 typography, fine cream stock, soft green pastel solids and a smokey-colored vellum all held in place with a square folder/cover and mailed in a clear vellum square envelope.

▶ Title: Letterhead box for Neenah Paper
Design studio: Ema Design Inc., Denver, CO
Design: Thomas C. Ema
Client: Neenah Paper
The Kimberly Writing Letterhead Box contains samples of letterhead paper, printed samples of paper, and a swatch-book with the paper held in place by a die-cut insert. The upscale redesign presents the product in a coordinated and distinctive manner.

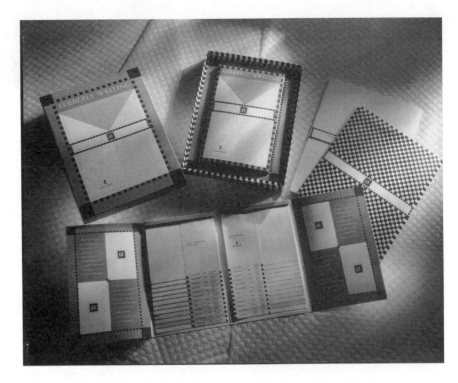

▼ Title: Magazine ads for MCC Construction Corporation
Design studio: Ema Design Inc., Denver, CO
Design: Thomas C. Ema
Photography: Allen Kennedy
Client: MCC Construction Corporation
The conceptual approach of the series communicates the ideas of cost, time, and management. Because of the actual construction work done by this company, we used striking photos and innovative typography to connect with their buying customers and facility managers.

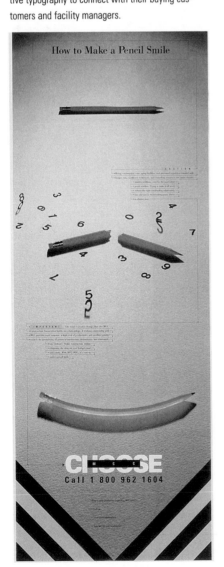

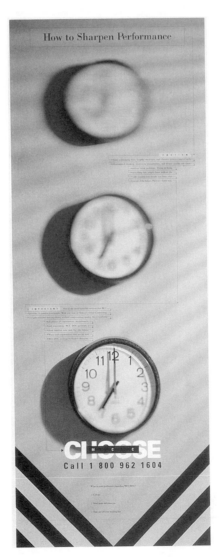

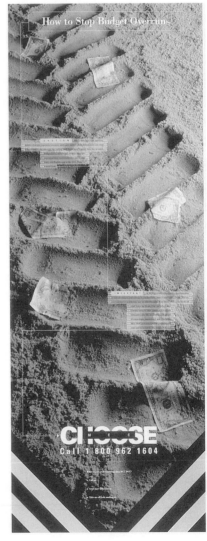

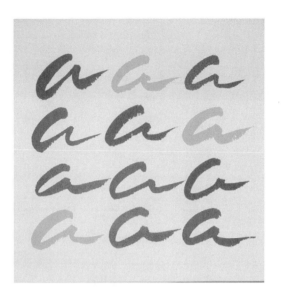

◀ Title: Logo for Artist's Angle
Design studio: Ema Design Inc., Denver, CO
Art direction/design: Thomas C. Ema
Illustration: Thomas C. Ema
Client: Artist's Angle
Artist's Angle Inc. is a graphic arts support
service. In order to create an identity that
connects with the artist in each client, the
letterforms were hand drawn and painted.
The primary colors refer to basic building
blocks of art, the common denominator
among creative clients.

GENIUS

IS THE CAPACITY TO SEE TEN THINGS

WHERE THE ORDINARY MAN SEES ONE

AND WHERE THE MAN OF TALENT SEES TWO OR THREE

ARTIST'S

ANGLE

INC

◀ Title: One of a series of theme postcards
for Artist's Angle
Design studio: Ema Design Inc., Denver, CO
Design: Thomas C. Ema
Client: Artist's Angle
These postcards were designed to comple-
ment and reinforce the new identity we
designed for Artist's Angle. As with the logo,
they are intended to touch the artist in each
of their clients. To achieve the desired effect,
we used hand-painted gestural illustrations
and matching primary colors.

Ema Design, Inc.

173

Russell Hassell

Russell Hassell, New York, NY

◀ Title: *Guaman Poma: The Colonial Art of an Andean Author,* exhibition catalogue

Design studio: Russell Hassell, New York, NY

Design: Russell Hassell

Client: Americas Society

Guaman Poma: The Colonial Art of an Andean Author was an exhibition about a seminal document of early seventeenth-century Peruvian history that conveys the effects of the conquest from the voice of the conquered. Since the document itself is black ink only, the design for the book reflected this simplicity. The uncoated cream paper stock was printed with black text and a second "parchment" color behind the drawings and large initials. The dark blue uncoated cover stock featured a full-bleed black map of the Andean world and a gold foil-stamp title. An overrun of the elephant-hide invitations to the opening were printed and used as a "parchment" tip-on cover illustration.

● I N D E P E N D E N T
 C U R A T O R S
 I N T E R N A T I O N A L

[circular logo text, reading around circles:] exclusively to organizing and circulating traveling exhibitions of contemporary art. ICI is a non-profit organization dedicated ● Founded in 1975,

● 799 Broadway, Suite 205
NYC 10003 Tel 212 254 8200
Facsimile 212 477 4781

◀ Title:
Independent Curators International, logo
Design studio: Russell Hassell,
New York, NY
Design: Russell Hassell
Client: Independent Curators International
Independent Curators Incorporated, known
by the abbreviation ICI, requested that their
letterhead include a brief statement describ-
ing their organization in as minimalist a
presentation as possible. I prepared a num-
ber of comps for the first design review, but
one hour before the presentation I had an
epiphany. Rather than create a mark and
include the corresponding text, I let the text
create the mark. The type prints black and
the bullets print red. Again, pre-computer
days, I spaced the type around each circle by
hand. Recently ICI became Independent
Curators International. The revised letter-
head was prepared in a fraction of the time
with Adobe Illustrator™.

▼ Title: *Forests Revisited,* exhibition catalogue
Design studio: Russell Hassell, New York, NY
Design: Russell Hassell
Client: Colombian Center

Forests Revisited was a small publication with a very limited budget and a press run of only 1,000. It's a 16-page self cover two-color job—a reddish brown
and a deep green—on 65 lb recycled cover stock. It was the intent of this assembly of Colombian artists to recapture the sense of the sublime when urban
dwellers are confronted by nature. I decided to give everyone a piece of nature with every book. The binding is a twig on the outside with a rubber band
looped around the ends and extending down the center of the signature. Reddish-brown branches were found in the flower district. The client was given
1,000 seven-inch-long twigs (cut with poultry shears by my wife) and a box of rubber bands. The books were assembled by the client as needed. This con-
frontation between urban dwellers and nature yielded not a sense of the sublime but blisters for Ellen.

▶ Title: *Dark Decor*, exhibition catalogue
Design studio: Russell Hassell, New York, NY
Design: Russell Hassell
Client: Independent Curators International

Dark Decor was a traveling exhibition of works by artists who use pattern and decorative elements as devices to camouflage the more sinister aspects of their work. The concept was reinforced by the catalogue's dust jacket, actual wallpaper in a lurid bronze and black metallic prepasted paper with black flocking. Since the taste police had been through Manhattan, I had to go out to Brooklyn to find something this wonderfully awful. The paper had just been discontinued but there was enough left in the supplier's warehouse to fill my needs— an overage from the redecorating efforts of a local cocktail lounge.

After finding the paper, the next hurdle was to figure out how to apply type. My printer, The Studley Press, in Dalton, Massachusetts, experimented with different applications. Foil stamping worked the best. The shiny bronze metallic foil stamped onto the paper had the added visual interest of changing texture as it went over the flocking. The printer cut individual sheets off the rolls, stamped the type, and folded them as dust jackets.

Only 750 books were produced since the exhibition had a limited tour. The catalogue sold out and the client expressed interest in doing a second printing. Of course, the wallpaper was no longer available.

Martin Holloway
Graphic Design

Martin Holloway, Designer and Professor and Chair, Department of Design, Kean University, Union, NJ

▼ Title: Logo
Studio: Martin Holloway Graphic Design, Warren, NJ
Design and hand-lettering: Martin Holloway
Client: Martin Holloway Graphic Design

▶ Top to bottom:
Title: Lettering for pharmaceutical promotion
Studio: Martin Holloway Graphic Design, Warren, NJ
Design and hand-lettering: Martin Holloway
Client: Schering Corporation

Title: Theme graphic for the call for entries poster
Studio: Martin Holloway Graphic Design, Warren, NJ
Design and hand-lettering: Martin Holloway
Client: Art Directors Club of New Jersey

▲ Title: Lettering for pharmaceutical promotion
Studio: Martin Holloway Graphic Design, Warren, NJ
Design and hand-lettering: Martin Holloway
Client: Schering Corporation

▼ Clockwise from top:

Title: Personal logo
Studio: Martin Holloway Graphic Design, Warren, NJ
Design and hand-lettering: Martin Holloway
Client: Mary Gale

Title: Holiday card graphic
Studio: Martin Holloway Graphic Design, Warren, NJ
Design and hand-lettering: Martin Holloway
Client: WCBS Television

Title: Personal logo
Studio: Martin Holloway Graphic Design, Warren, NJ
Design and hand-lettering: Martin Holloway
Client: Joyce Tucker

Title: Cultural events brochure lettering
Studio: Martin Holloway Graphic Design, Warren, NJ
Design and hand-lettering: Martin Holloway
Client: Kean University of New Jersey

Title: "Let's Form a Bond," promotional lettering
Studio: Martin Holloway Graphic Design, Warren, NJ
Design and hand-lettering: Martin Holloway
Client: Martin Holloway

Liska + Associates, Inc.

Studio: Liska + Associates, Inc., Chicago/New York
Left to right: Steve Liska, Susanna Barrett, Alberto Cristancho, Marcos Chavez, Aimee Sealfon

▼ Title: AIGA salary survey
Design studio: Liska + Associates, Inc., Chicago/New York
Design: Susanna Barrett
Photography: Frederik Lieberath
Client: AIGA

The American Institute of Graphic Arts (AIGA) produced a survey on standards of compensation within the graphic design field. Liska + Associates designed a booklet to present this information, available to AIGA members and nonmembers interested in comparing salary packages. The design includes images of unusual currencies from other cultures, reinforcing the concept that compensation is more than a dollar amount and should be considered a whole package with a relative value.

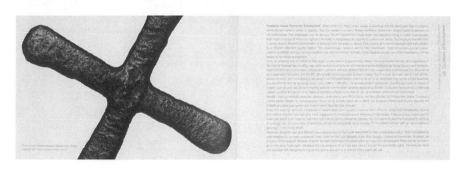

► Title: *Fordham* University alumni magazine Winter 1999

Design studio: Liska + Associates, Inc., Chicago/New York

Art direction: Susanna Barrett, Liska + Associates Inc.

Design: Al Cristancho, Liska + Associates Inc.

Cover Illustration: Anders Wenngren

Client: Fordham University

Fordham University is a private, liberal arts university based in New York City. Liska + Associates redesigned *Fordham*, the quarterly alumni magazine to serve their readership more effectively, as well as speak to a more general audience. *Fordham* commissioned an article on ethics for the winter 1999 issue. The cover design utilized simple line illustrations of human faces connected together, evoking the universal nature of the issue. Throughout the article, illustrations representing specific disciplines were connected with a continuous line and were rendered in the same simple and evocative style. Type and color supported the universality of the theme of ethics with simple letterforms and a black/gray/white color scheme.

► Title: Mark Havriliak Company Management *Document*

Design studio: Liska + Associates, Inc., Chicago/New York

Creative direction: Steven Liska, Liska + Associates Inc.

Art direction: Marcos Chavez, Liska + Associates Inc.

Design: Susanna Barrett, Liska + Associates Inc.

Photography: Mark Havriliak

Client: Mark Havriliak Company Management

Document began as a joint project between Company Management Models and photographer Mark Havriliak. Liska + Associates developed the hardcover art book to promote the image of the modeling agency and to market its models to a broader range of clients. The book functions as an industry documentary, offering the models a voice and an opportunity to represent their points of view. Both the modeling agency and the photographer sent this book out to current and potential clients.

Tom Payne

Tom Payne
Waverly, IA

◀ Tom Payne's CD-ROM art and design piece entitled "Sometimes," was featured in the *1997 Communication Arts Interactive Annual.* "Payne's intent was totally nonlinear. Meaning is created by what we see."
— from CA commentary

This piece is a fascinating, outrageous, frustratingly fun interactive animation that gets you to think fast about image juxtaposition and visual perception — along with other layers of psychological and sociological suggestion and comment. We excerpted a fraction of Payne's compositions from the CD. However, it is best viewed dynamically. Copies can be obtained through: CEPA Gallery in Buffalo, NY (http://cepa.buffnet.net/) or contact Tom Payne directly, at thomaspayne@uswestmail.net

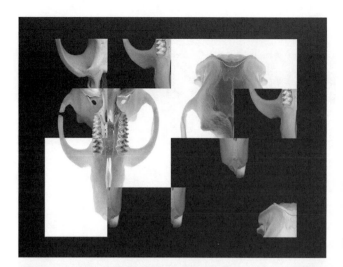

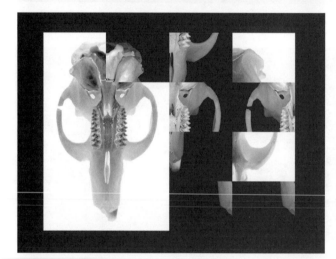

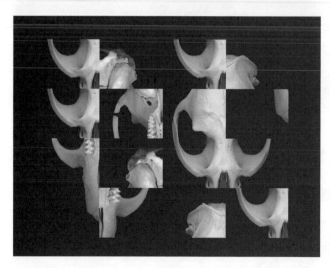

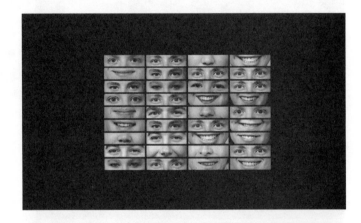

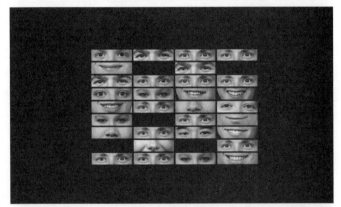

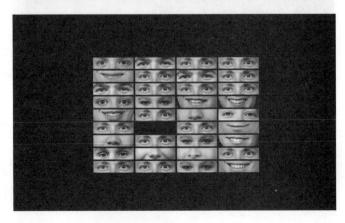

point **b** incorporated

The design team at point **b**
Honolulu, HI

▼ Title: AIGA mailer — calendar of events
Design studio: point **b** incorporated, Honolulu, HI
Art direction: Alvin Wong
Design: Alvin Wong
Client: The American Institute of Graphic Arts (AIGA-Honolulu)
The AIGA is a national organization promoting excellence in graphic design. This
project promotes some of the events that have taken place in Hawaii.

aiga/honolulu chapter business card show 10.10 - 10.31
academy art center
hours: mon/closed, tues-sat 10 - 4:30, sun 1 - 5
reception: oct 10, 5:30 - 8

the aiga/honolulu chapter will be exhibiting business cards
designed by several of our local members. the exhibit displays
the diversity of technique and style to reinforce the messages
brought forth from each unique card.

aiga studio tour 10.22
the shiller group, 810 richards st. suite 200
time: 4 p.m.

there is a limit of 20 people so please call early to make your
reservation. call ito design associates at 847-2833 or e-mail at
ida@lokahi.com all studio tours are free for aiga members
and $10 for non-members.

adobe 10.28
uh art building, room 101, the mall
time: 6:30 - 8:30

adobe will be presenting photoshop 4.0 and after effects 3.1.
don't miss out on the latest information and give aways!
members and students are free, all non-members are $5.

aiga calendar of events october ninety7

10. 10. 22. 28. 31 97

a | american institute of graphic arts non-profit organization

design by point b incorporated e-print donated by HON:BLUE

the american institute of graphic arts honolulu chapter inc
p.o. box 22845 honolulu, hawaii 96823

10.97

AIGA

non-profit org
us postage paid
honolulu, hawaii
permit no. 9790

the american institute of graphic arts has been established to ensure the advancement of excellence in graphic design as a discipline, profession,
and cultural force. the aiga provides leadership in the exchange of ideas and information, the encouragement of critical analysis and research,
and the advancement of education and ethical practice.

for more information about aiga/honolulu, upcoming events or becoming a member, please call our
hotline: 526.aiga, or visit the aiga/honolulu web site at www.aiga.com/honolulu
membership info: randal ouye 539.3777
web: www.aiga.com/honolulu

october calendar of events aiga

► Title: HTDC annual report

Design studio: point **b** incorporated, Honolulu, HI

Art direction: Lynn Kinoshita, Alvin Wong, Marlene Lee

Design: Lynn Kinoshita, Alvin Wong, Marlene Lee

Client: High Technology Development Corporation (Hawaii)

Photography and three-dimensional aspects were used to create depth and a large range of value using two colors.

► Title: *HWIN* magazine cover

Design studio: point **b** incorporated, Honolulu, HI

Art direction: Alvin Wong

Design: Alvin Wong

Client: Hawaii's Web and Internet News Publication

Monthly magazine focuses on new technological developments in Hawaii, specifically, Internet service providers. Imagery portrays the sudden expansion of the Internet industry.

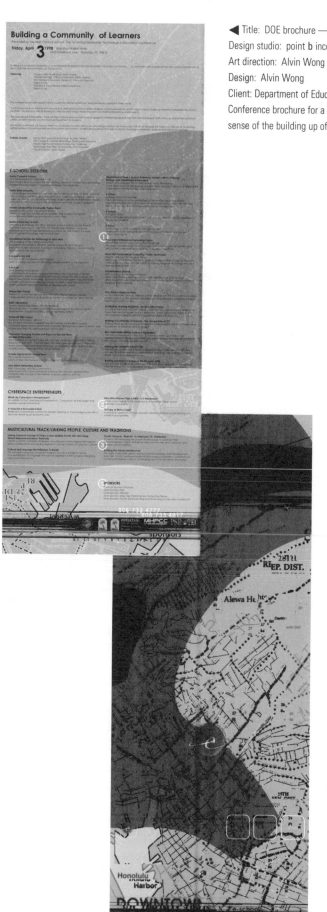

◀ Title: DOE brochure — mailer
Design studio: point **b** incorporated
Art direction: Alvin Wong
Design: Alvin Wong
Client: Department of Education (Hawaii)
Conference brochure for a Statewide Technology Education Conference. Layering of streetmaps on Hawaii gives sense of the building up of a community and at the same time reflects a digital, microchip kind of feel.

▼ Title: Web site (www.hawaii.htdc.org/)
Design studio: point **b** incorporated, Honolulu, HI
Art direction: Alvin Wong
Design: Alvin Wong
Client: High Technology Development Corporation
The High Technology Development Corporation is a state run organization that works toward developing a critical mass of technology companies to make Hawaii high technology business competitive in the global market. Layering of text and imagery combined with text rollovers give the site added interactivity.

point **b** incorporated

187

► Title: point b web site (www.point-b.com)

Design studio: point b incorporated, Honolulu, HI

Art direction: Alvin Wong

Design: Alvin Wong

Client: point b

The point b site focuses on the experimental, pushing the limits of html and design to extremes while maintaining function and fast downloads. Navigation is contained in a separate window and can be hidden for better viewing of the main site by simply clicking the dancing "b" animation. The combination of photography and text layout create evocative imagery and evoke a sense of fluidness throughout the site.

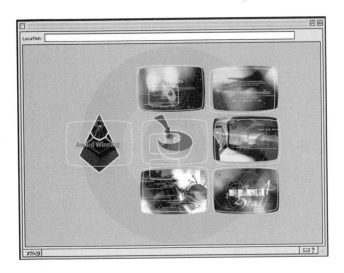

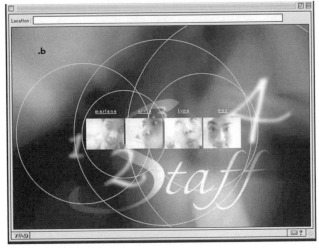

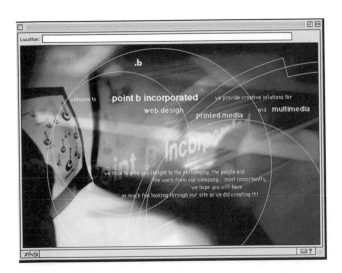

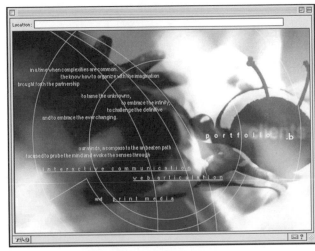

Jefferson Rall

Jefferson Rall
St. John & Partners, Jacksonville, FL

◀ Title: *Mildred Thompson* catalog
Design studio: St. John & Partners, Jacksonville, FL
Art direction: Jefferson Rall
Design: Jefferson Rall
Client: The Jacksonville Museum of Contemporary Art
With a busy schedule this year for the Jacksonville Museum of Contemporary Art, it was my challenge to make sure this catalog communicated the unique aspect of this particular show. Mildred Thompson, a Jacksonville native and internationally recognized artist, was exhibiting for the first time in her hometown. I utilized the mystic aspect of her abstract style and the celebratory feel of her homecoming, having lived abroad most of her life, to create a vibrant contrast to the other catalogs being produced by the museum this year. Handwritten type and a brilliant color palette reflected her own crafted, abstract style.

▶ Title: Blood Brothers poster
Design studio: St. John & Partners, Jacksonville, FL
Art direction: Jefferson Rall
Design: Jefferson Rall
Client: FCCJ Drama Works

Ken Mucullah, the director of the FCCJ Theatre Program and director of Blood Brothers (a contemporary British musical by Willy Russell) needed a small two-color poster to help advertise the performance to the threatre going audience. The tone he was hoping to get across in the musical was a mixture of nostalgia and street toughness.

The new theatre program had a large budget for the musical production but a small advertising budget. Only 125 posters were requested to place in strategic locations common to the theatre-going crowd.

In order to cut through some of the traditional (and crowded) theatre wall clutter, we decided to actually go four-color instead of two (an inexpensive plateless process was chosen). We gave the poster a collage style feel that played up the nostalgic, emotional side of the story. The photography used was original family photos from the 1960s. This solidified the nostalgic feel as well as helped to define a time frame for the play.

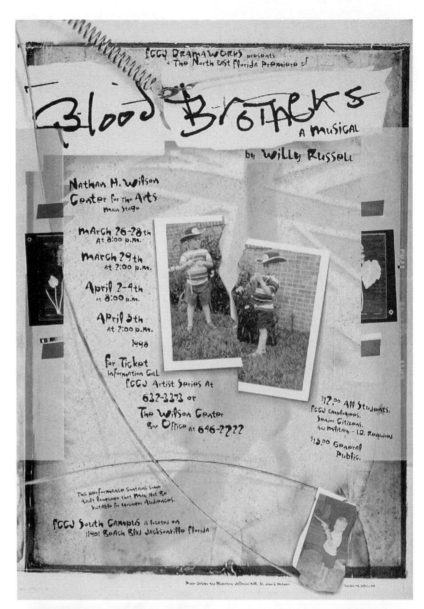

▶ Title: Stationery package
Design studio: Robin Shepherd Studios
Art direction: Jefferson Rall
Design: Jefferson Rall
Client: Jennifer Kring

Jennifer Kring needed a simple stationery package. She was starting her own Dietary Consulting firm as a young nutrition expert. The package would be her first form of communication launching her new self-owned business.

My plan was to design the stationery in such a way as to give her new company an exciting, authentic look. We both wanted to engage and excite potential clientele. If this was all she could afford, it had better be good. It was the only self-promo piece she would be sending out for a while.

After the first go-round she decided to merge a four color version with a die-cut version. After a revise, we were both thrilled with the way the stationery worked together as a corporate package. She liked the impact of the bright apple photography so much that she decided to get funding that would support the cost of doing four color printing.

The results have been outstanding. Jennifer's clients appreciate the high standard of her services as well as the follow-through of a fun, identifiable communications system.

▼

Title: *Primed for Life* source guide
Design studio: St. John & Partners, Jacksonville, FL
Art direction: Jefferson Rall/Rob Semos
Design: Jefferson Rall/Rob Semos
Client: SONY and PRIMCO

When PRIMCO came to St. John & Partners, they were underserviced and out of time. They needed to have a PR plan (as well as supporting material) to launch a new store location in the college town of Gainesville, Florida.

The co-sponsor of the launch, SONY, read our proposal and loved it. They focused their efforts on the college market and sponsored the *Primed for Life* source guide, so named by the design team at St. John & Partners.

We wanted the book to sell the new launch of the store without being too commercialized. We had to speak to the college market in a design style that was youthful, fun, and hip, without being too trendy. Things like a football schedule, year-at-a-glance calendar, and an important campus phone directory were included.

PRIMCO worked closely with us on developing special college marketing promotions and helped to inspire some of the local merchants (as well as national ones) to advertise in the source guide with half-page coupons, a valuable feature for college kids.

Overall, the book came out great, and ended up a huge success. The launch was the best launch for PRIMCO in any Florida city ever.

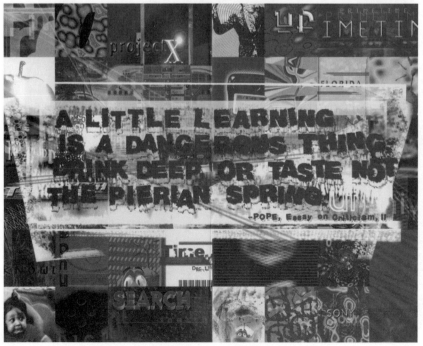

Jefferson Rall

Segura, Inc.

Carlos Segura
Segura, Inc. Chicago, IL
Segura Incorporated was born from the frustrations of Carlos Segura's 13-year career in advertising — opening its doors in January 1991 to pursue design and its tangible and personal possibilities. Drawn to the print medium, all forms of materials were based on three basics: typography, papers, and fine art. Fueled by curiosity, experimentation was a primary direction in all efforts leading to the development and creation of [T-26], a new digital type foundry, making its debut in the fall of 1994. Another form of expansion has been multimedia, web site and interactive presentations — all with the philosophy that "communication that doesn't take a chance, doesn't stand a chance."

Segura is one designer who fuses creative ideas with the creative manipulation of the physical elements. Every piece from Segura Inc. is a visual surprise.

▼ Title: Posters (part of a series) for *Alternative Pick* sourcebook
Design studio: Segura, Inc. Chicago, IL
Creative direction: Carlos Segura
Design: Carlos Segura
Client: The Alternative Pick

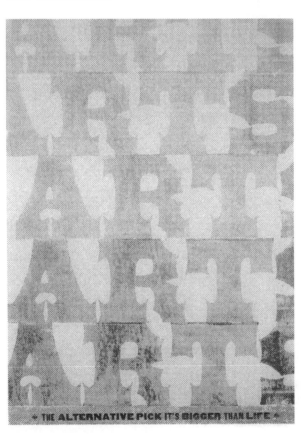

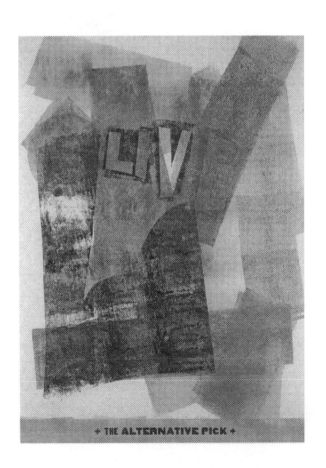

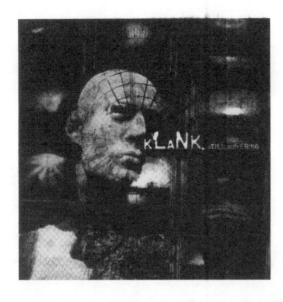

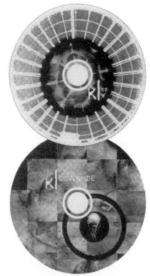

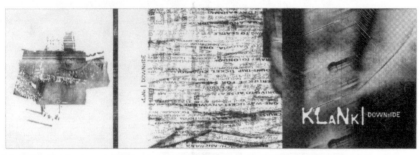

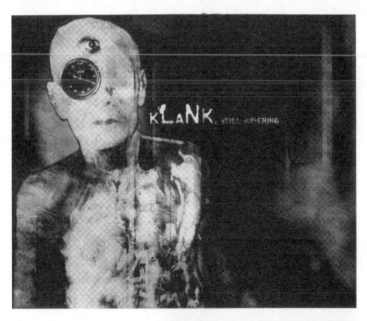

◀ Title: Full length CD, CD single,
cassette, and poster elements for Klank
Design studio: Segura, Inc. Chicago, IL
Creative direction: Carlos Segura
Art direction: Carlos Segura
Design: Carlos Segura
Photography: Jim Marus
Client: Tooth & Nail Records

Segura, Inc.

► Title: Corporate identity campaign
Items include: 3/4-inch video cassette label, letterhead front and
back, mailing label, business card front and back, #10 envelope
front and back, note card front and back, logo.
Design studio: Segura, Inc. Chicago, IL
Creative direction: Carlos Segura
Design: Carlos Segura
Client: Celsius Films

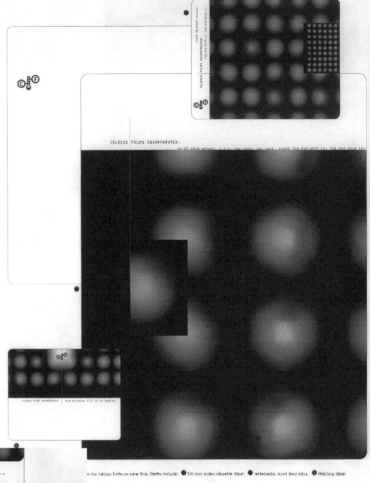

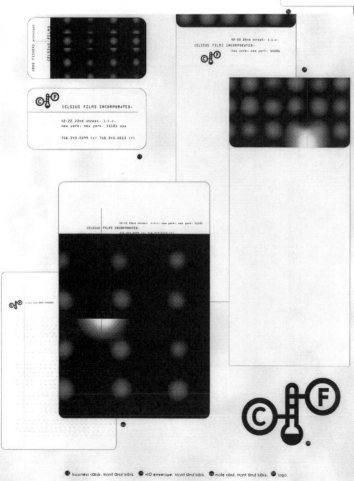

▶ Title: Snowboard designs
Design studio: Segura, Inc. Chicago, IL
Creative direction: Carlos Segura
Design: Carlos Segura
Client: XXX Snowboards

▶ Title: *The Alternative Pick* limited edition box-set sourcebook
The Alternative Pick limited edition box-set sourcebook contains: two posters,
four pencils in assorted colors, two bookmarks, a series of 40 stickers, a t-shirt,
postcards, a calendar, and the sourcebook itself. Produced in four leather colors.
All enclosed in the handmade, 200 line, four-color process, silk-screened box.
Design studio: Segura, Inc. Chicago, IL
Creative direction: Carlos Segura
Design: Carlos Segura
Client: The Alternative Pick

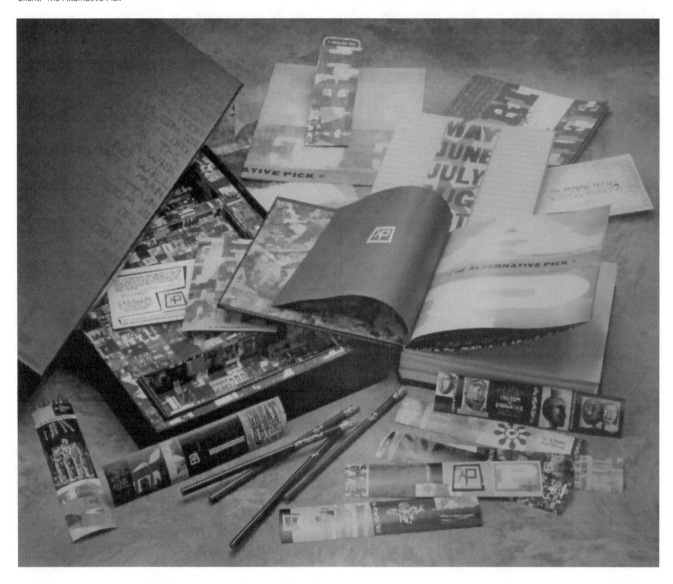

Mary Ann Smith
Design and Illustration

Mary Ann Smith Design and Illustration,
New York, NY

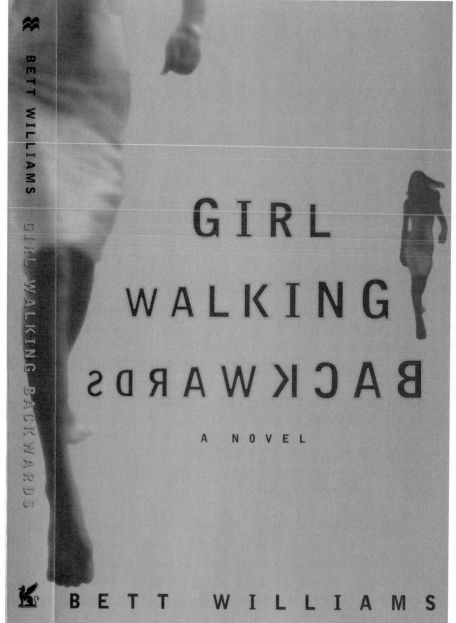

◄ Title: Book jacket for
Girl Walking Backwards
Studio: Mary Ann Smith Design and
Illustration, New York, NY
Designer: Mary Ann Smith
Photography: Kei Uesugi/Photonica
Client: Saint Martin's Griffin

▶ Title: Book jacket for the *Necessary Hunger*
Studio: Mary Ann Smith Design and Illustration, New York, NY
Designer: Mary Ann Smith
Client: Saint Martin's Press

▼ Title: Book jacket for *Breaking Out of Food Jail*
Studio: Mary Ann Smith Design and Illustration, New York, NY
Designer: Mary Ann Smith
Photography: 1995 Photo Disk, Inc.
Client: Simon and Schuster

Stuart Topper

Stuart Topper
Metuchen, NJ

▼ Title: Antiquarium, covered vessel
Design and Construction: Stuart Topper
Materials: Walnut, beech, maple, Corian, Lexan, metal leaf
Photography: Klaus Schnitzer

Stuart Topper, artist, designer, and Professor, Fine Arts Department,
Kean University, Union, NJ
Photo: Stephen Spartana

Creativity is both mental and physical gymnastics. It is tested regularly and massaged by situations and solutions that are challenging and to a lesser or greater degree, rewarding. It is an energy which reveals mysteries, provides new options or remanufactures old ones. It spits out connections, some old, some new, some others a remix of the encyclopedia of one's experiences. Often it is a confirmation, sometimes an aberration.

Creativity makes life interesting. It keeps us in flux, asks us to be adaptive or to instigate new directions. It causes frustration, but more often personal reward. It is a mantle we wear and the glasses we see life through. I feel so lucky to be blessed with this vision, this lifestyle, and that those on the receiving end of my creativity, feel that experiencing my art has been meaningful to them.

◄ Title: Halogen lamp
Design and Construction: Stuart Topper
Materials: Corian, brass, perforated aluminum
Photography: Klaus Schnitzer

▶Title: Candlestix
Design and Construction: Stuart Topper
Materials: Poplar, purpleheart, maple, copper
Photography: Klaus Schnitzer

▼ Title: In Memory of Eric: Entombed Cigars (For Eric Hummel,
who died of AIDS in 1996)
Design and Construction: Stuart Topper
Materials: Walnut, maple, brass, Corian, glass, fabric, cigars
Photography: Klaus Schnitzer

▼ Title: The "Orb"
Design and Construction: Stuart Topper
Materials: Purpleheart, poplar, brass, maple, flocking, metal leaf
Photography: Klaus Schnitzer
Collection of: Mr. and Mrs. E. Austin Goodwin

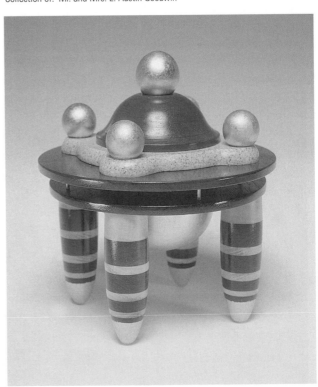

Viva Dolan
Communications & Design

▼ Title: B&R Biking & Walking catalogues 1998

Design studio: Viva Dolan Communications & Design Inc., Toronto,
Ontario, Canada

Design: Frank Viva

Writing: Doug Dolan

Photography, principal: Ron Baxter Smith

Photography, additional: Macduff Everton, Hill Peppard, Steven
Rothfeld et al.

Illustration: Malcom Hill

Client: B&R

The catalogues published annually by Butterfield & Robinson are
designed to reinforce B&R's position as the world leader in biking
and walking vacations for a sophisticated, upscale North American
clientele. A key element in the design solution was the creation of
a trip page that communicates a wealth of multitiered information
in an attractive, easy-to-use format. The trip page is in effect
B&R's sole showroom and must convey all the practical data, as
well as the emotional-aesthetic allure, that a client needs in order
to make a very high-ticket purchase. At the same time, B&R's cata-
logue is eagerly anticipated by loyal travellers (repeat business
accounts for a large share of annual revenue) who view it as a
reflection of their own refined tastes and cultural awareness. Each
new catalogue therefore must look great, offering a distinctive
visual approach that inclines recipients to keep it on their coffee
tables. This year B&R created a heightened sense of occasion by
publishing two companion books, *The Great Walks of the World*
and *The World's Great Biking Journeys*, underlining the fact that
the pioneer in top-quality biking trips now leads the field in walk-
ing as well.

Frank Viva and Doug Dolan
Viva Dolan Communications & Design Inc., Toronto,
Ontario, Canada

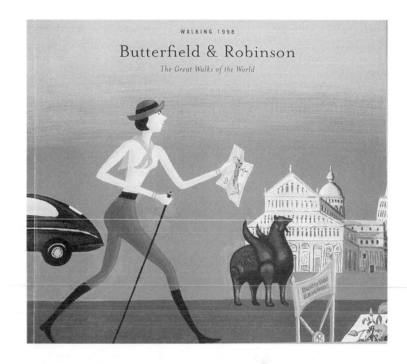

▶ Title: *Let's Sell Ourselves* (Hard Copy)

Design studio: Viva Dolan Communications & Design Inc., Toronto, Ontario, Canada
Design/Illustration: Frank Viva
Writing: Doug Dolan
Client: Viva Dolan

We always tell our clients that the best way to differentiate yourself is to do some-
thing different. So when we set out to create a marketing piece for our own firm, we
tried to follow our own advice. We wanted to sell the combined crafts of art direction,
illustration, and writing that formed the basis of our partnership. We also wanted to
make clear that we are an idea-driven firm. We wanted to show samples of our work
without the static presentation of a catalogue. And we wanted to send something that
would be noticed and saved. Inspired by the 1950s storybooks of our youth — many of
which happened to be lying around our offices for a project we were doing for Golden
Books — we created a story in words and pictures that sells Viva Dolan with the
directness, simplicity, and humor of a children's book.

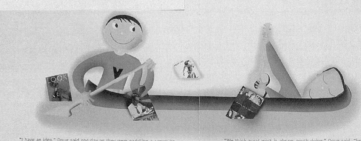

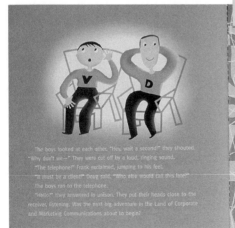

A LOSS FOR WORDS

P E N C A N A D A
FIGHTING FOR FREEDOM OF EXPRESSION

◀ Title: A Loss For Words poster

Design studio: Viva Dolan Communications & Design Inc., Toronto, Ontario, Canada

Design/ Illustration: Frank Viva

Writing: Doug Dolan

Photography: Hill Peppard

Client: PEN Canada

"A Loss For Words" is a poster created for the Canadian branch of PEN, the international writers' organization that fights for freedom of expression around the globe. The creative mandate was to communicate, graphically and memorably, PEN's key message: that repressive regimes which imprison, torture, and even execute writers, simply for what they have written, are robbing the world of a precious commodity. The poster therefore conveys a dual "loss for words" — the horror and frustration felt by the writer who is silenced, and the deprivation experienced by the community at large. The illustration is painted directly onto pages from a novel by Aleksandr Solzhenitsyn, himself a victim of enforced silence in the Soviet gulag.

▼ Title: YMCA of Greater Toronto annual report

Design studio: Viva Dolan Communications & Design Inc., Toronto, Ontario, Canada

Design: Frank Viva

Writing: Doug Dolan

Illustration: Matt Mahurin, Doug Guilford, David Goldin, Paul Dallas, Gary Baseman

Photography: Russell Monk, Hill Peppard, Patrick Harbron, Jim Allen

Client: YMCA of Greater Toronto

The annual report is the Toronto YMCA's chief marketing vehicle for its many community programs and the centerpiece of all publicity, fundraising, and membership-building. A phrase from the YMCA's vision statement — "the heart of a healthy community" — provided a unifying thematic thread for the annual report. We invited ten well-known photographers, illustrators and artists to contribute works inspired by a series of heart-related phrases. Alternating with these visual spreads are narrative "chapters" designed to give the report a literary feeling while further underlining the human element that is central to everything the YMCA tries to achieve. Sharing our enthusiasm for the project, contributing artists generously agreed to work for only a small honorarium, which enabled us to include dramatic visuals without eroding the tight budget. Indeed, the strength of these artists' works was such that we could print the report on very inexpensive paper without losing visual impact, thereby realizing a further cost saving. The report was extremely well-received, attracting many new participants and drawing record-breaking contributions to the YMCA's community fundraising and capital campaigns.

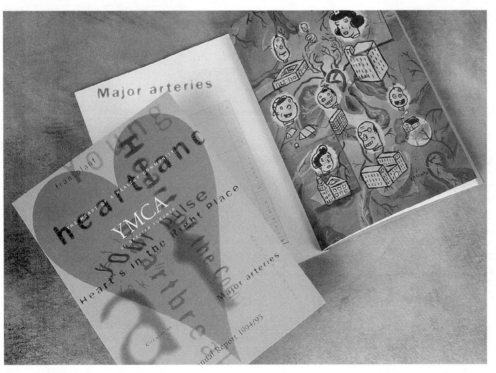

▼ Title: Advertising & Design Club of Canada
Re: Entry poster

Design studio: Viva Dolan Communications & Design Inc., Toronto, Ontario, Canada

Design/ Illustration: Frank Viva

Writing: Doug Dolan/ Frank Viva

Client: Advertising & Design Club of Canada

"Re: Entry" is a call for entries poster produced for the Advertising & Design Club of Canada as part of the promotional campaign for the club's awards show and annual. The poster and various collateral pieces try to capture the interest of a creative audience by blending hard information (awareness of the competition, deadline, venue, and so on) with ironic commentary on the very nature of awards competitions. The litany of tongue-in-cheek "reasons for entering" taps into some of the commonly expressed reservations people in the industry have about ad and design awards. The ultimate goal of the poster, which mixes computer illustration with an actual photo of a 1950's designer, is to encourage entries (and financial support) by showing entrants that the organizers share their sense of irony and ambivalence yet, on balance, still believe that it is an enterprise worth supporting.

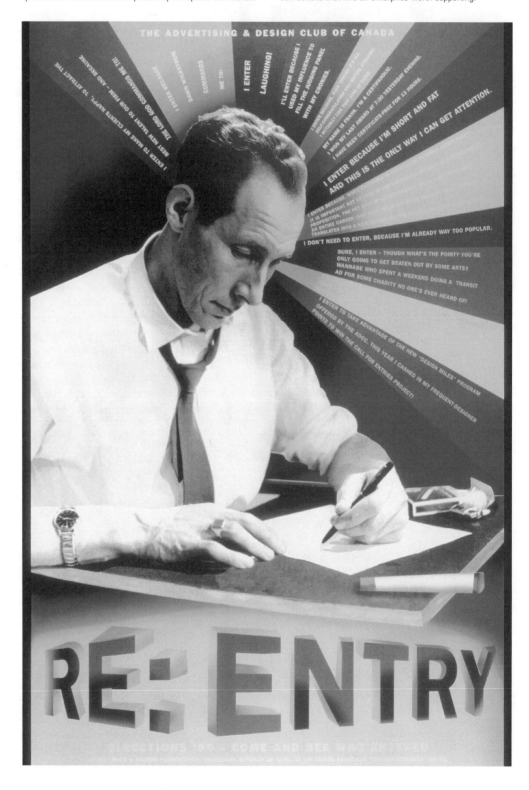

Vrontikis Design Office

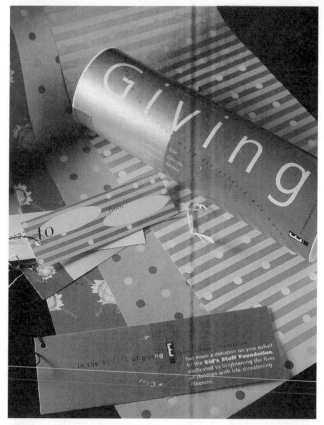

Petrula Vrontikis
Vrontikis Design Office, Los Angeles, CA

◀ Title: E! Entertainment promotional
Studio: Vrontikis Design Office, Los Angeles, CA
Art direction: Petrula Vrontikis
Design: Susan Carter
Client: E! Entertainment Television
This nondenominational holiday promotion for the affiliates, friends, and clients of
E! Entertainment Television includes wrapping paper and "To & From" tags. It cen-
ters around E! giving a gift that keeps on giving. The word "giving" was translated
into ten languages and woven through the design. The enclosed card makes the
concept clear, stating that a donation has been made in the recipient's name to
the Kid's Stuff Foundation.

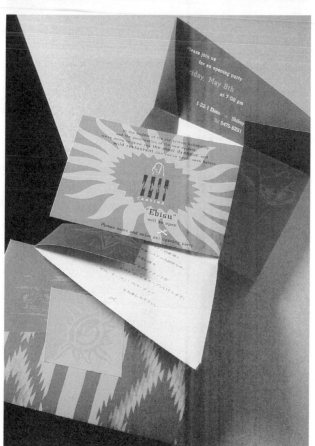

▶ Title: Zest Cantina invitation
Studio: Vrontikis Design Office, Los Angeles, CA
Art direction: Petrula Vrontikis
Design: Tammy Kim
Client: Zest Cantina
Zest Cantina is a wild and fun Tex-Mex restaurant with seven locations in Tokyo,
Japan. This opening invitation for the largest Zest Cantina illustrates the boldness
of the decor and cuisine. The client requested a funky, southwest American look.

Vrontikis Design Office

▶ Title: 2-Lane Media identity
Studio: Vrontikis Design Office, Los Angeles, CA
Art direction: Petrula Vrontikis
Design: Susan Carter
Client: 2-Lane Media
2-Lane Media (founded by brothers David and
John Lane) is a leading web site design and pro-
duction company in Los Angeles. The reference to
an eclipse, combined with a progressive type
treatment illustrates a combination of technology
and creativity.

▶ Title: FIDM scholarship poster
Studio: Vrontikis Design Office, Los Angeles, CA
Art direction: Petrula Vrontikis
Design: Petrula Vrontikis
Photography: Scott Morgan
Client: Fashion Institute of Design and Merchandising
This Fashion Institute of Design and Merchandising poster and mailer announces a contest to apply for five scholarships being offered to high
school students. The dancing figure on the left and the dancing typography on the right represent imagination, creativity and exploration of
ideas.

 Note: I found the original image for "dancing type" in an antique handbook that my grandmother owned on etiquette in speech and
writing.

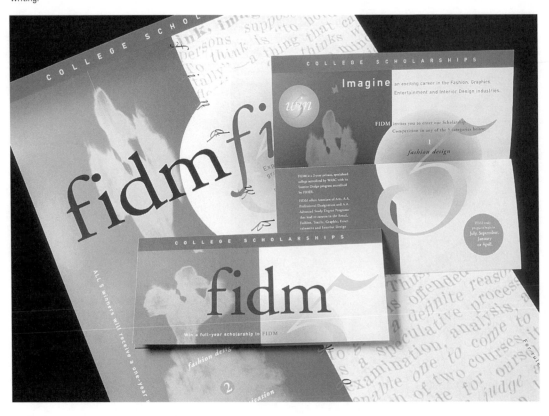